AROUND
RUGELEY

A Further Selection

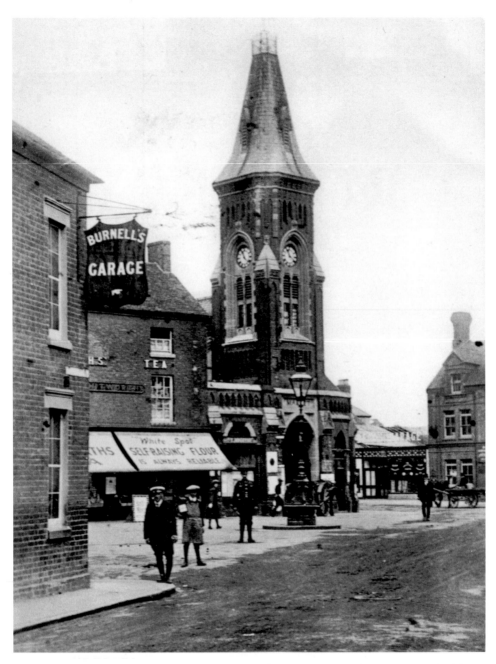

Market Place, Rugeley, about 1920. The clock tower is part of the Town Hall building which included an assembly room above the market area. Dances held in the assembly rooms were popular with local people. Degg's Garage can be seen behind the Town Hall, and Whitworths the grocers to the left of the drinking fountain.

AROUND
RUGELEY

A Further Selection

From Old Photographs

THEA RANDALL & JOAN ANSLOW

AMBERLEY

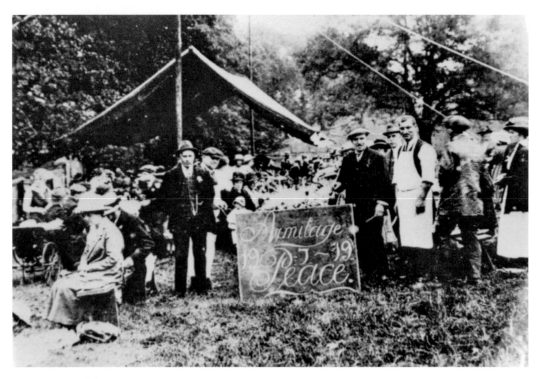

Peace Celebrations, Armitage, 1919.

First published 1996
This revised edition published 2010

Amberley Publishing Plc
Cirencester Road, Chalford,
Stroud, Gloucestershire, GL6 8PE

www.amberley-books.com

British Library Cataloguing in Publication Data.
A catalogue record for this book is available from the British Library.

ISBN 978 1 84868 502 4

Typesetting and Origination by Amberley Publishing.
Printed in Great Britain.

Contents

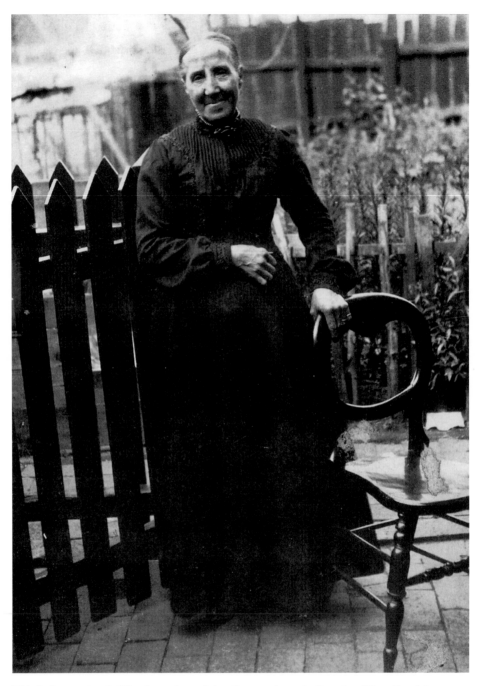

This lady was Annie Wood, mother of the Cornet player in Rugeley Silver Band (see page 117). She was born in Lichfield Workhouse in 1848 and was brought up by her grandparents, Thomas and Sarah Handley, in Colton. She attended Bellamour School and later became a midwife. This photograph was probably taken in Queen Street Rugeley.

Introduction

The town of Rugeley is situated in the Trent Valley, with Cannock Chase, an area of outstanding natural beauty, to the west. The river valley has always provided a natural route for communications and, in the eighteenth century, the main London-Holyhead road came through the town. It was followed by the Trent and Mersey Canal, the first to be constructed in Staffordshire, which was completed between 1766 and 1777. For many miles the river and canal lie within a stone's throw of one another. The subsequent development of the railway network also brought the railway to the valley in the form of the Trent Valley line of the London and North Western Railway, which opened in 1847.

The importance of communications to the development of Rugeley was recognised even at the beginning of the nineteenth century, when George Cooke, a topographical writer, described Rugeley as 'a handsome well built town... with a large manufactory of hats and felts... Between the town and the River Trent is the Grand Trunk Canal where there is a large warehouse for the stowage of goods.' While the presence of the canal was a significant factor in Rugeley's development, so was its situation on the Cannock Chase Coalfield. In the early nineteenth century mines were already being worked at nearby Brereton by local landowners such as the Marquis of Anglesey and Earl Talbot, later the Earl of Shrewsbury. By 1841 Brereton Colliery was employing 227 persons. The later nineteenth and early twentieth centuries saw further investment at Brereton, but, for Rugeley itself, it was probably the 'winning' of Lea Hall Colliery during the 1950s which was most significant in the town's more recent economic history, leading as it did to the opening of two large power stations and the growth of large housing developments on the edges of the town. Although the mining industry was the major employer in the area, other industrial developments took place at nearby Armitage, where, by 1868, Edward Johns had established his sanitary earthenware factory, later to become worldfamous as Armitage Shanks.

In 1811 Thomas Pennant, another traveller, focussed on another aspect of Rugeley, which town, he wrote, was 'celebrated for its great annual horse fair for horses of the coach breed. Certainly, between the eighteenth and the early twentieth centuries the annual June fair was a major event in the town, when it was said it was impossible to move in the Horsefair for the sheer number of horses.

Gentlemen – and those who were not so genteel – came to Rugeley from as far away as Scotland and Ireland to trade in horses.

Despite Rugeley's growth as a mining community, it continued to act very much as the local market town for the villages in its hinterland. These followed the pattern of English rural life, being dominated by agriculture and related trades and crafts. By the eighteenth and early nineteenth centuries a surprising number of country houses, both large and small, could be found in the surrounding countryside, such as Hagley Hall on the edge of the town itself, Hawkesyard Park, Wolseley Hall, Bellamour Hall, Bishton Hall and, a little further away, Shugborough Park. None of these houses were perhaps more influential in Rugeley than Beaudesert, home from the sixteenth century of the Paget family, later created Marquesses of Anglesey. A large Elizabethan house standing on Cannock Chase, it was remodelled in the Gothic style in the late eighteenth century, restored to the spirit of the sixteenth century by the sixth Marquis at the beginning of this century, and, sadly, demolished in the 1930s. The landed families who owned these houses were important in the life of the town and the nearby villages as landlords, employers, benefactors and conspicuous consumers.

In compiling this collection of photographs of Rugeley and its surrounding villages, we have tried to illustrate many aspects of past life – schooldays, work, leisure, celebration and sadness – as well as to include scenes which have disappeared forever. Many pictures have been drawn from private collections and will not have been seen before. But inevitably there are gaps. Bringing together a collection of archive photographs is not an easy process. Compilers are dependent upon the original whim of bygone photographers and must then hope that someone, somewhere will have preserved the pictorial evidence which those photographers produced. Then comes the task of tracking it down. The number of names in the Acknowledgments gives an indication of how many people can be involved in helping in a publication like this. It is both a rewarding and a frustrating process; rewarding when one strikes gold with a hitherto unpublished collection of private photographs, but equally frustrating when, time after time, one fails to strike lucky with a particular hamlet or village. It is to be hoped that a by-product of a book such as this will be to reinforce the importance of preserving old photographs for future generations to enjoy.

THEA RANDALL
JOAN ANSLOW

One

The Changing Scene

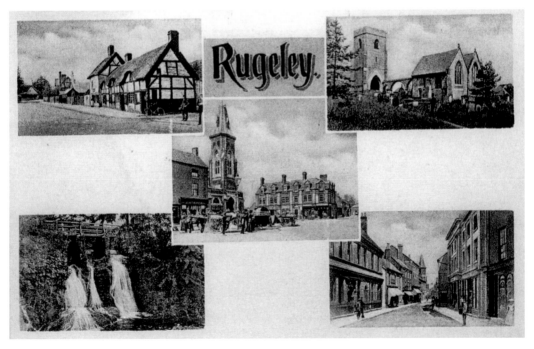

A multiple view postcard of about 1905. Top right: the Old Chancel and churchyard; Centre: Market Place bustling with people and carts; Top left: Thatched cottages at the corner of Elmore Lane and Sandy Lane; Bottom left: The waterfall at Slitting Mill, a popular picnic area; Bottom right: Lower Brook Street.

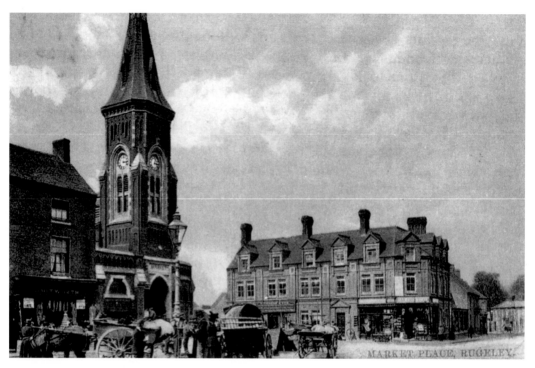

Market Place about 1905. Harris' Ironmonger's shop is on the corner and sides of bacon can be seen in Whitworths, the Grocers. Market day was as much a social as a commercial occasion.

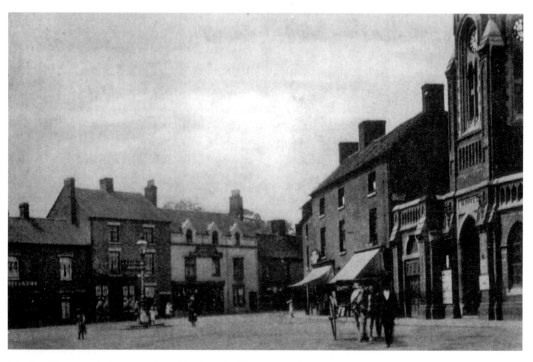

Market Place, again in 1905, but this time looking towards Bow Street.

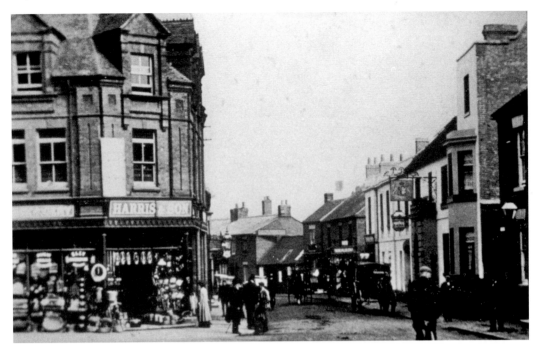

Market Street in the early twentieth century. Harris and Son display a fine selection of household articles from hurricane lamps to buckets and pans. The Inn sign is that of the Talbot Arms, later renamed the Shrewsbury Arms.

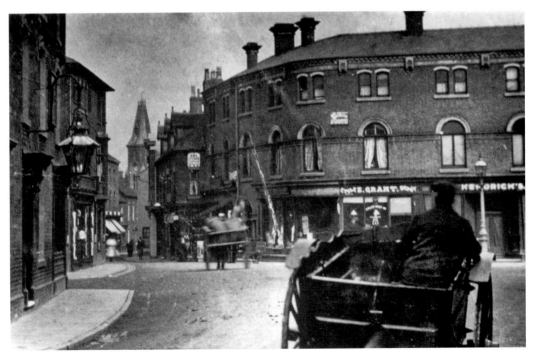

Brook Square about 1905, showing the curved row of shops still to be seen today.

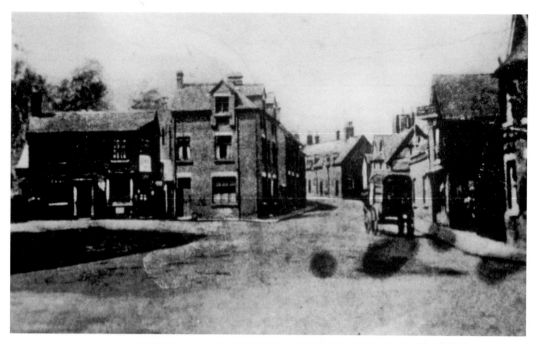

Sheep Fair 1910. The Vine Inn is on the right. Above the baker's cart can be seen the gable end of a timbered building, which was once an inn called the White Lion. This stood on the corner of Sheep Fair and the street which gave it its name, Lion Street.

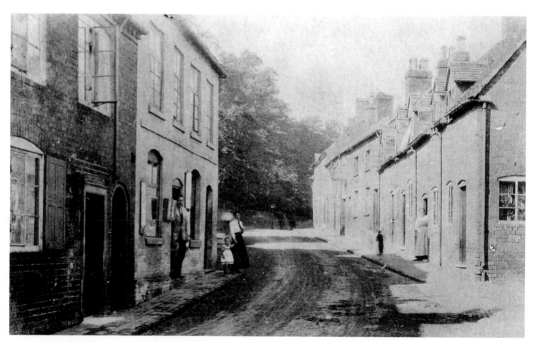

Further up Sheep Fair, again in 1910. Some of these cottages were demolished in 1957 to make way for an ambulance Station.

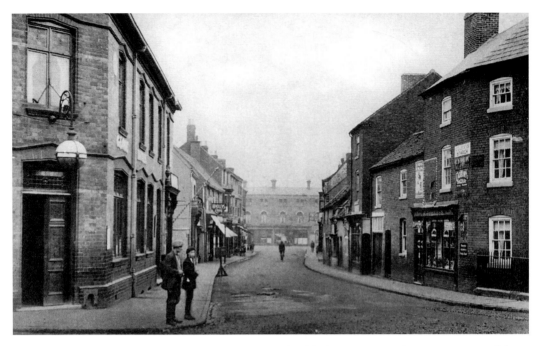

Upper Brook Street contained two of the licensed public houses in Rugeley in 1922. One of these, The Globe, is on the left hand side of this photograph. Between The Globe and The Crown was Mrs Orpe's vegetable shop.

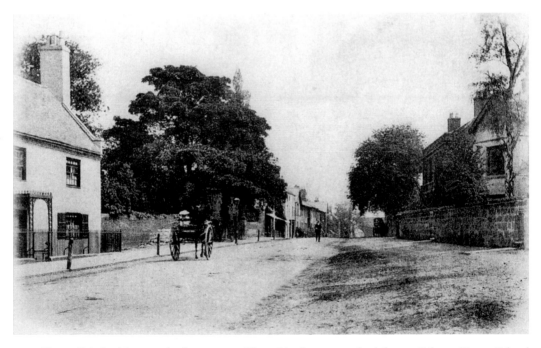

Horse Fair looking south about 1914. The white house on the left was Selwyn House School for Girls.

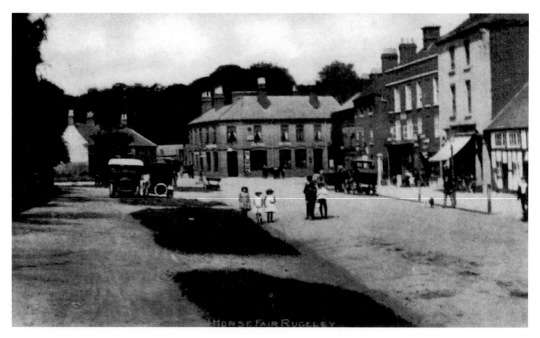

Horse Fair, 1914, the annual Fair, held in June. The posts on the edge of the pavement had rope put through them to tether the horses and afford some of protection to the public. The message written on the back of this postcard reads: 'This is the most important Street in Rugeley.'

These thatched cottages were in Horse Fair. The gypsies, who came for the horse fair sometimes parked their caravan at the side of these houses.

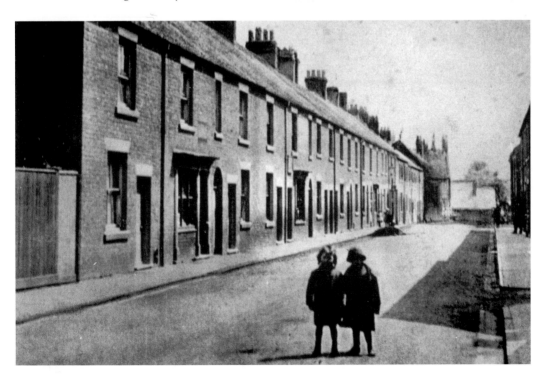

Right: The junction of Sandy Lane and Horse Fair, showing the thatched cottages which used to stand on the corner of Elmore Lane.

Below: Lion Street in the 1920s, a typical terrace of neat little houses. Note the delivery of coal in the gutter outside one of the houses. This would have to be barrowed through an entry to the back.

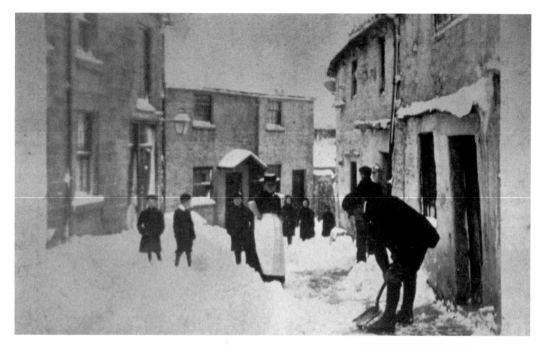

The 'Great Freeze' in 1893. This scene shows the people of Church Street digging their way out.

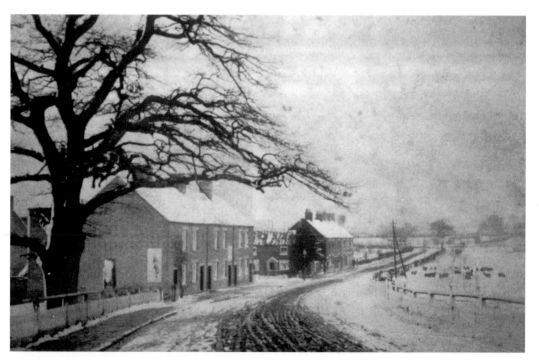

Station Road in Winter.

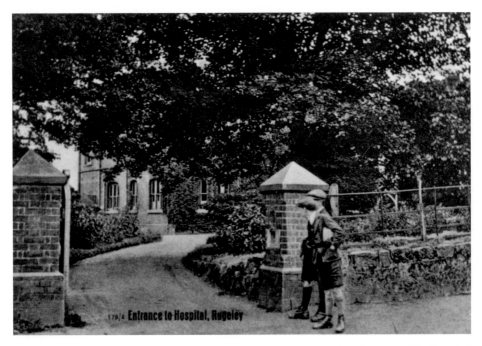

These lads are peeping round the side of Rugeley District Hospital in the 1920s. The hospital has now been demolished and new housing and facilities for the elderly built on the site.

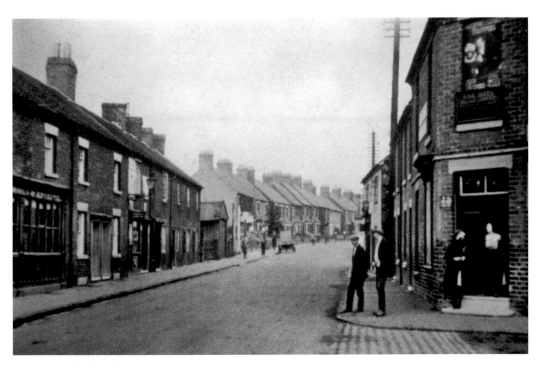

Brereton Road in the early 1920s.

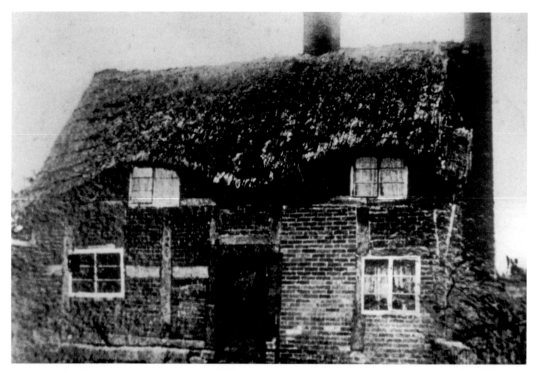

An old house in Brereton Road, pictured about 1929. At one time, before their own Church was built, the Congregationalists held services here.

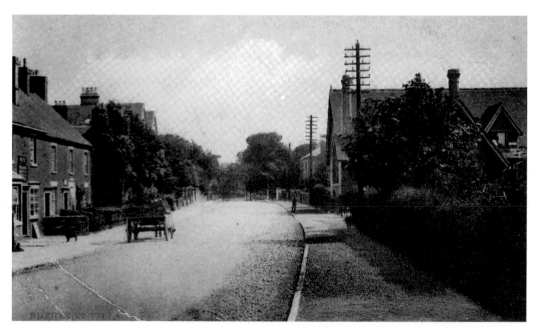

The road through Brereton village in 1910. This quiet scene has now vanished for ever, to be replaced by a busy dual-carriageway and new housing development.

Armitage Road about 1905, with the railway bridge in the background.

Rectory Lane, Armitage. These houses were built in 1909 for the employees of Edward John's Sanitary Earthenware Pottery.

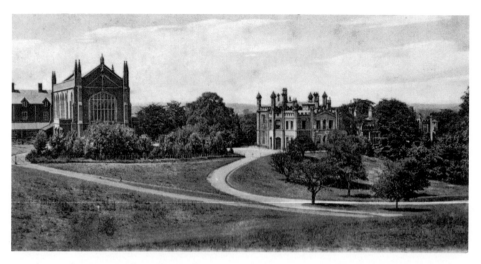

Hawkesyard Priory and College, Armitage, in the 1920s. Josiah Spode, the owner of Hawkesyard Park, bequeathed it to the Dominican Order on his death in 1893. By 1898 they had built a church and priory there.

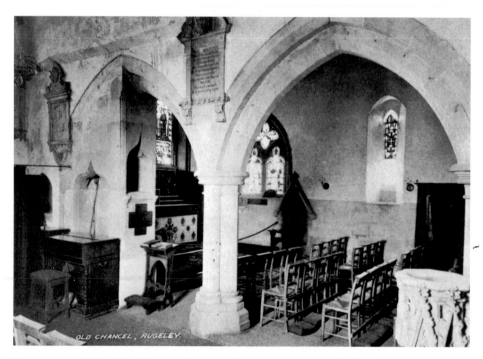

The interior of the Old Chancel, Rugeley, about 1905, originally the parish church until St Augustine's was built in 1822.

The Stafford Road at Wolseley in 1905.
Always prone to flooding in the winter, this
road has now been widened and the level
raised above the low-lying fields on the left.

The road from Wolseley, looking towards
Rugeley, about 1930.

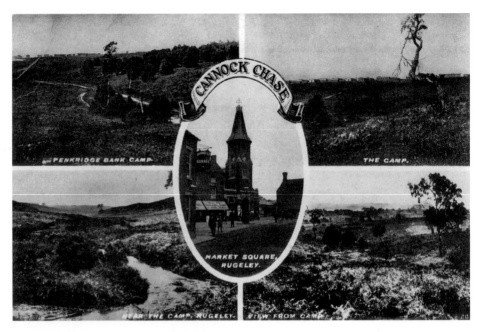

Cannock Chase, an area of hills and heathland, was used as a hunting ground in medieval times. This multiple view postcard was issued during the First World War and shows views of the army camp which was built on the Chase near Rugeley.

Fairoak in the 1920s. The lane on the left leads to Slitting Mill. The one on the right goes to Etching Hill.

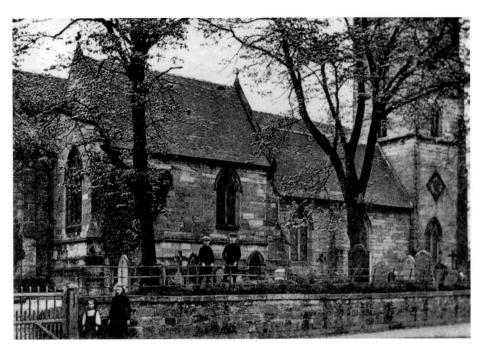

St Michael's Church, Colwich, early in the twentieth century.

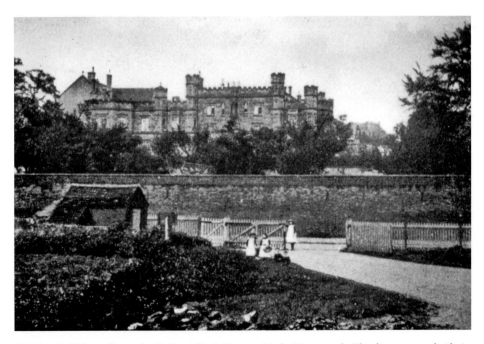

St Mary's Abbey, formerly St Benedict's Priory, Little Haywood. The house was built in about 1730 and later enlarged by Viscount Tamworth in 1825. He called it Mount Pavillion. The house was sold in 1835 to a group of French Benedictine nuns and has been an abbey ever since.

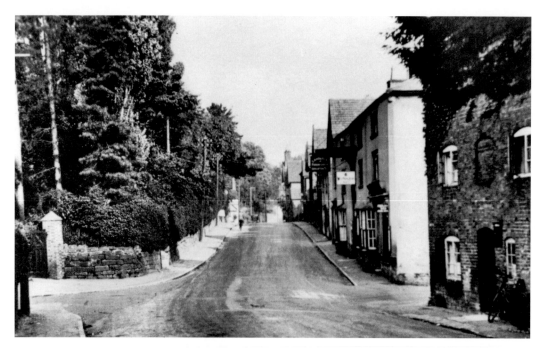

The main village street, Little Haywood. The three-storied house on the right has now gone. The entrance gate on the left at the bottom of Coley Lane led to High Chase, formerly called Wren's Nest. The milestone is still in the same place!

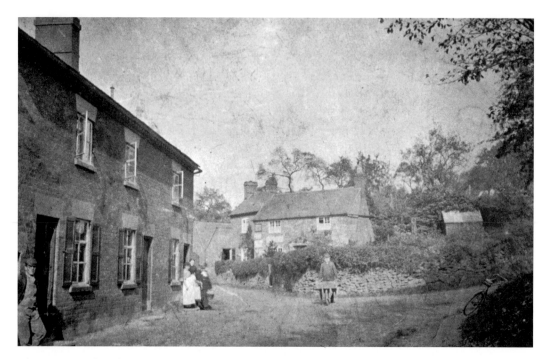

The junction of Back Lane with Coley Lane, Little Haywood, in 1904.

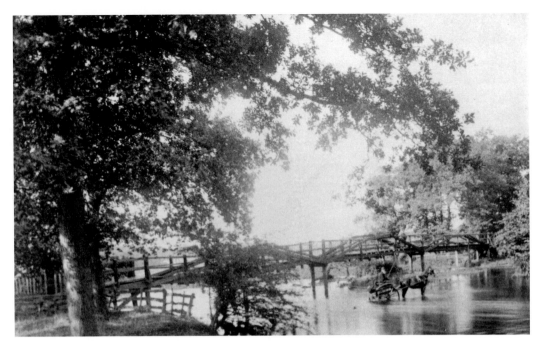

This wooden bridge was built over the ford at the bottom of Meadow Lane about 1830. It was replaced in 1887 by the present bridge known as Weetman's Bridge. This postcard view pre-dates 1887.

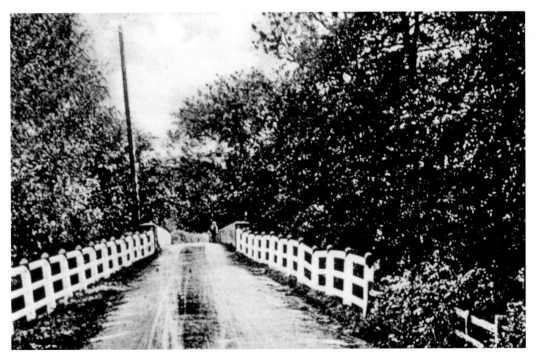

An unusual view of Weetman's Bridge.

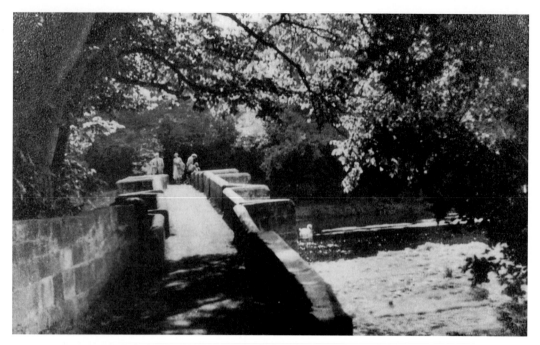

Essex Bridge, Great Haywood, always a popular place for a Sunday afternoon outing.

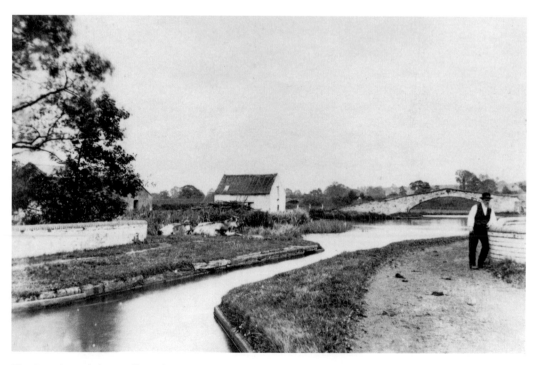

The junction of the Staffs and Worcester and the Trent and Mersey canals at Great Haywood. Photographed in 1867.

A view of Hixon village about 1910.

High Street, Hixon, in the 1920s. These and other old cottages, which were the heart of the village, were all demolished in the 1920s, and eventually replaced by modern housing.

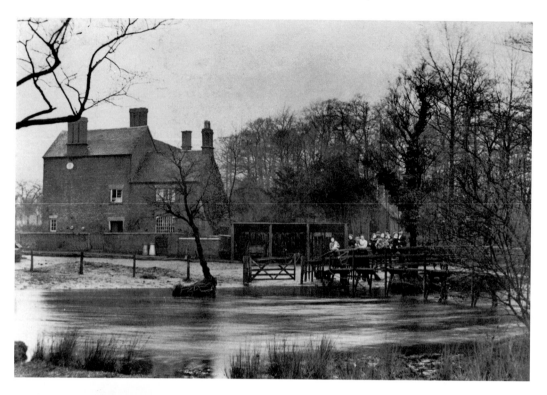

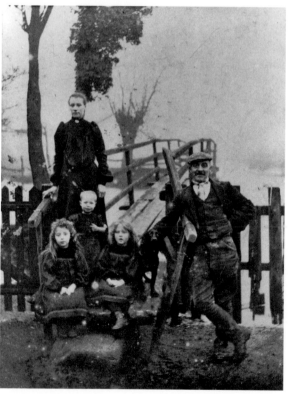

Above: Priory Farm, Blithbuy, about 1905. The Mycock family are pictured on the footbridge over the River Blythe. Joseph Mycock was the owner-occupier of the farm, and his father, James, who died in 1902, had farmed there before him. Note the milk churns by the wall.

Left: A close-up photograph of Joseph Mycock, his wife, Elizabeth, and three of their children, Edith, Elsie and Alice. This photograph was taken on the same footbridge, presumably on the same day.

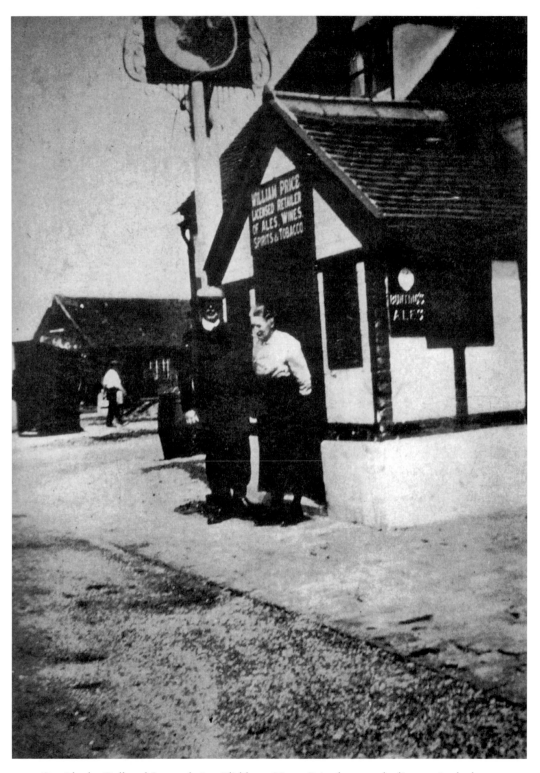

Outside the 'Bull and Spectacles' at Blithbury. Henry Price became the licensee in the late 1920s.

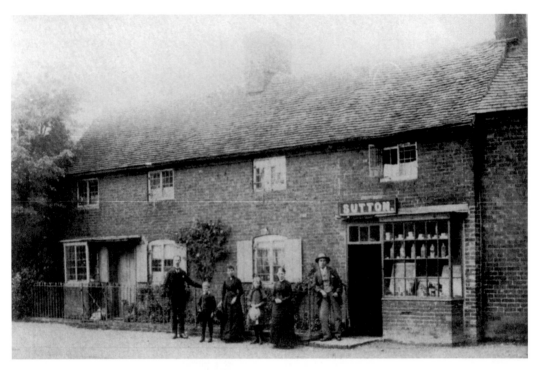

Sutton's grocer's shop at Hamstall Ridware about 1890.

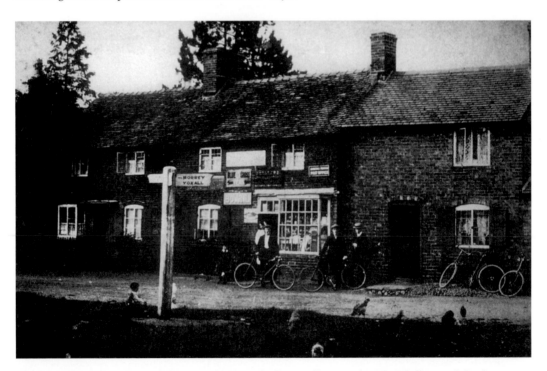

The same shop about 1910. It has now become the Post Office, run by Mrs Phillips and displays a profusion of advertising signs.

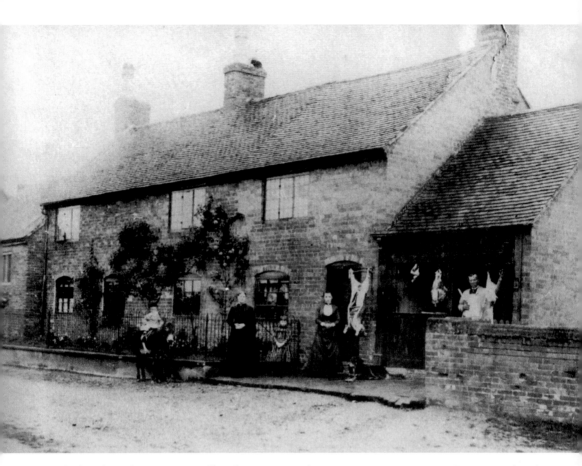

The butchers shop in Hamstall Ridware, again about 1890. It was opposite Sutton's and Jack Ashmore, pictured on the right, was the butcher. The slaughterhouse was the building on the extreme right.

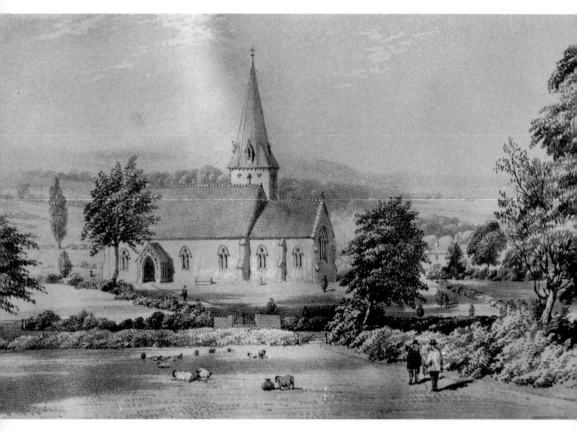

A view of St Peter's Church, Hixon, in 1855, just a few years after the building of the church in 1848.

Two

Dawn Till Dusk

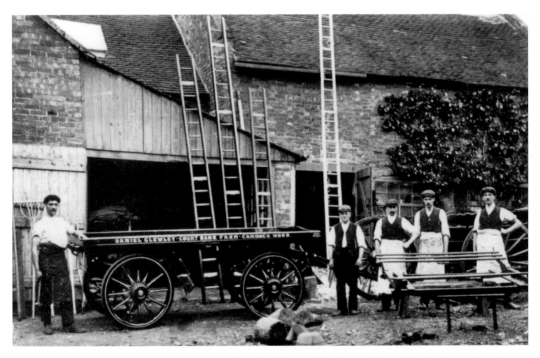

Outside the barn at Elm Farm, Great Haywood, owned by the Bradbury family, farmers and blacksmiths. The farm was demolished in 1967 and modern houses now stand on this site. This photograph was taken about 1910.

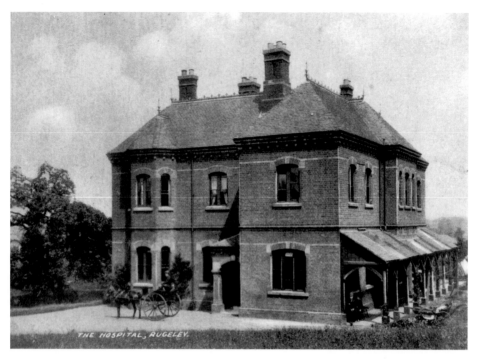

The District Hospital and Provident Dispensary, Brereton Road, Rugeley, was built in 1879 at a cost of £1,299. The Earl of Lichfield donated the land and the building costs were met by public subscribers, headed by Mr Horsfall of Bellamour Hall, Colton.

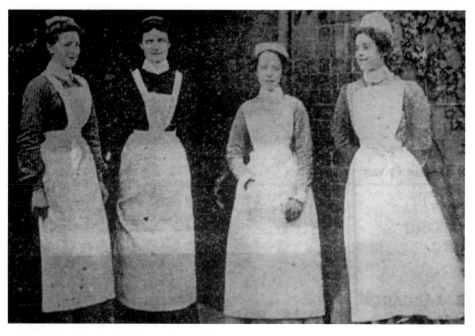

Nurses at Rugeley Hospital, 1906.

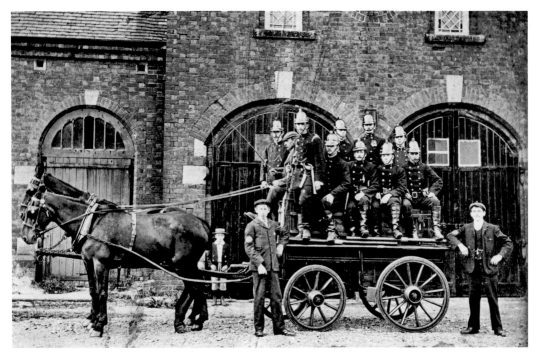

Rugeley Volunteer Fire Brigade about 1910. The fire bell was in the tower of the Town Hall and was rung whenever the firemen were needed.

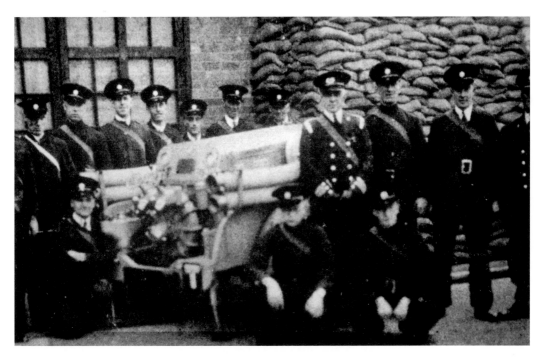

Rugeley's Auxiliary Fire Service during the Second World War. Note the pile of sandbags in the background.

The post office at Slitting Mill. This post office was run from a private house for 60 years.

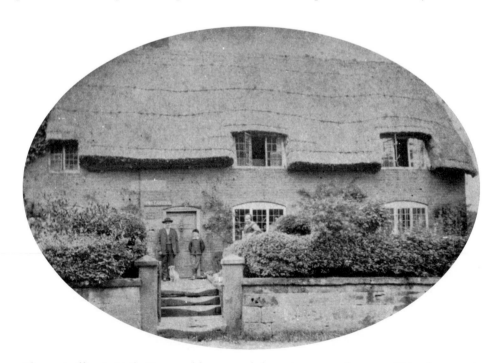

The post office in Little Haywood has moved three times over the years. This photograph taken in the early 1880s shows the first one. The thatched cottage fronted onto the main road just below the Red Lion public house and before the corner of Coley Lane. John Cliff, the postmaster, is pictured with his wife and grandson, George.

Trent Lane, Great Haywood. The village shop on the corner is now a private house and the post office is opposite.

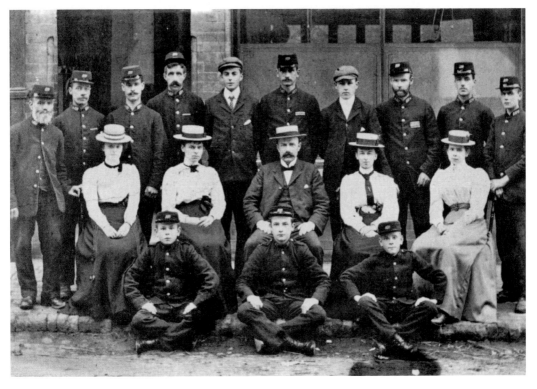

The staff at Rugeley post office about 1905.

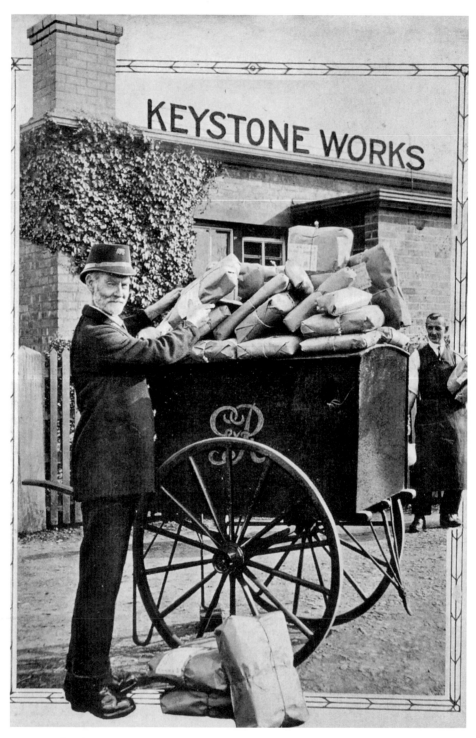

Henry Parker, born 1865, was a postman in Rugeley for many years. A quiet man, known as 'silent Henry' he is seen here filling the mail cart with parcels from Keys, a mail order tailoring firm.

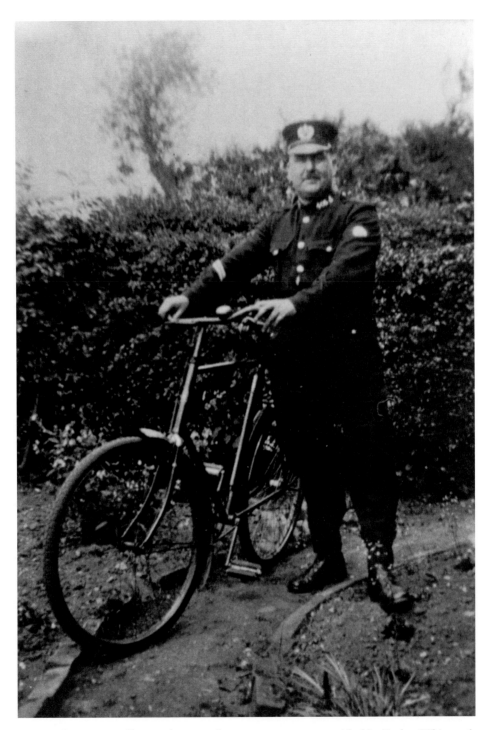

Mr Craik, Hixon village policeman from 1921 to 1937, with his Rudge Whitworth Coventry bicycle with triangular mudguards. The Chief Constable of the time disapproved of his men 'scurrying about on bicycles' and also would not allow them to wear Wellingtons in bad weather. 'Policemen should not look like deep sea fishermen!'

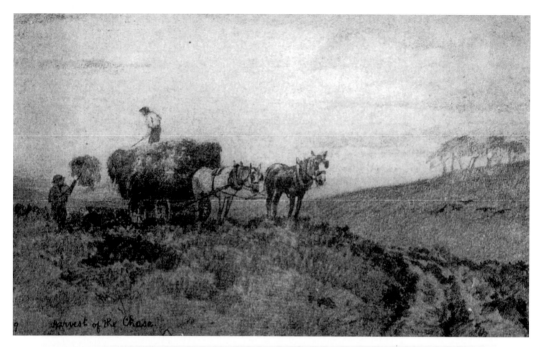

Harvesting the Chase. Bracken was used as bedding for cattle and was also burned to make ash, an ingredient in soap manufacture.

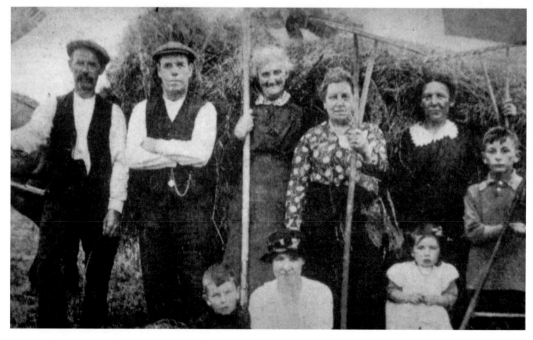

Haymaking in the Common Lanes, Rugeley about 1912.

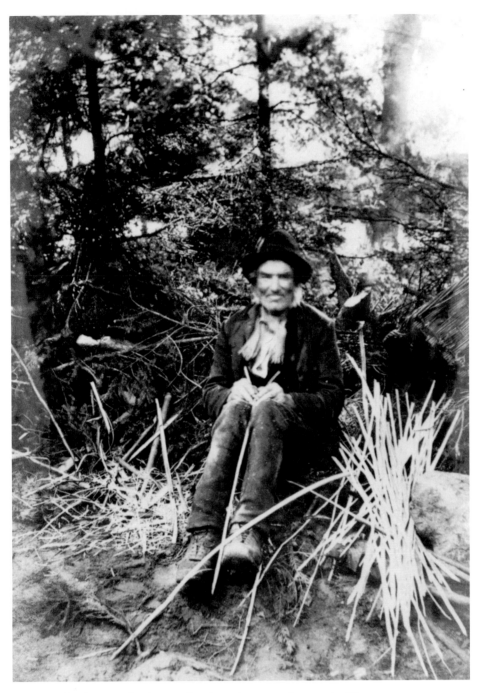

A very early photograph of 1867 showing a besom maker on the Chase.

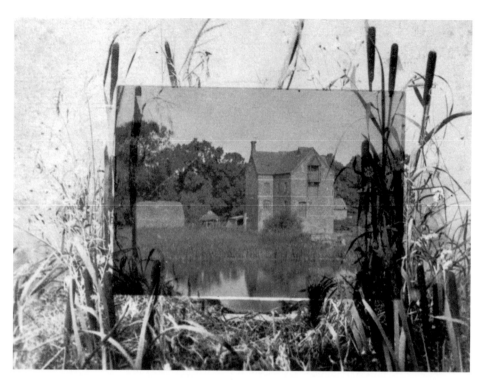

An idyllic view of Haywood Mill with superimposed bullrushes to make a greetings card.

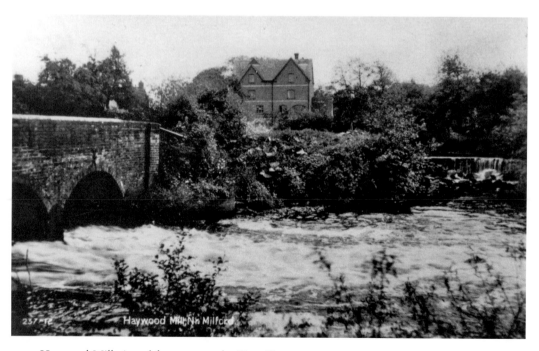

Haywood Mill viewed from across the River Trent.

This authoritative gentleman is thought to be Lancelot Neighbour, agent to Lord Bagot of Blithfield Hall. He once accused an estate worker of not addressing him as 'Sir'. The man looked up from the hedge he was layering and said, 'I calls you Sir fust thing in a morning and that has to last you all day!' He was sacked and reinstated many times!

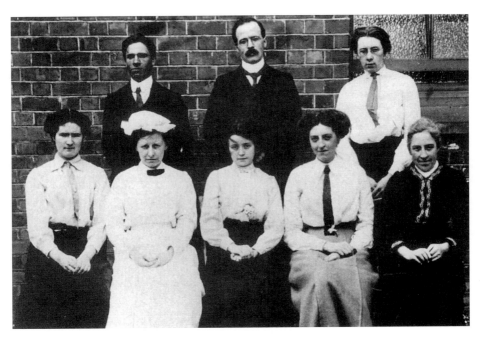

Staff at Colwich Church of England School in 1905.

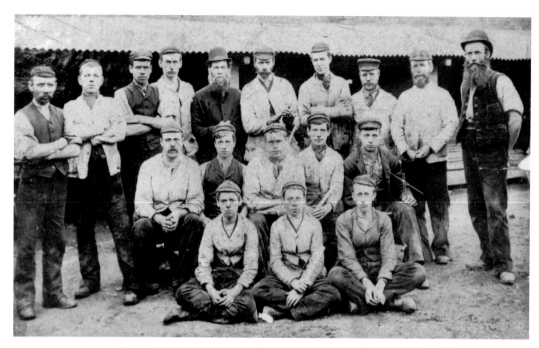

Workers at Woodruffe's Mechanical Engineers, Rugeley, during the early 1890s.

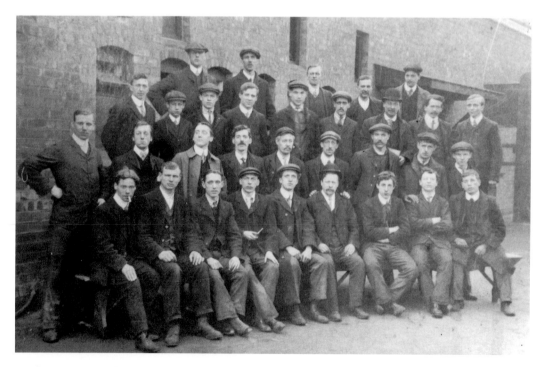

Workers at Woodruffe's about twenty years later.

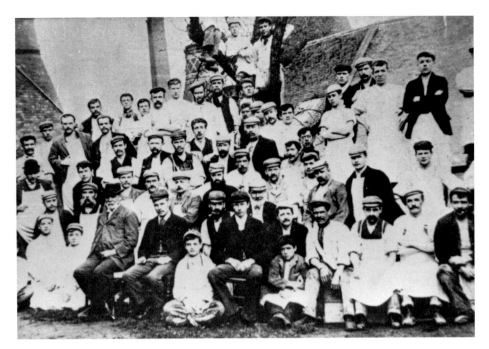

Workers at Edward John's Sanitary Earthenware Factory at Armitage, about 1890. The young man seated in the centre may be Edward Johns the younger, while the older man on the left may be Edward Johns senior.

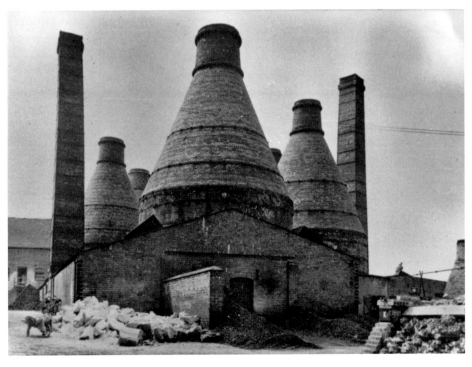

Kilns at Armitage Pottery.

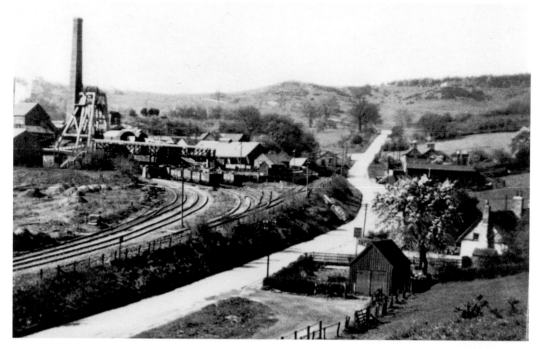

The Hayes Colliery, Brereton, seen here in 1947. There is virtually no trace left of this pit, which started production in 1817. Only the cottage on the right remains, which was much loved by American soldiers stationed nearby during the Second World War, when it was the Holly Bush Inn.

Pitworkers' houses at Hayes Colliery. These too are now demolished.

The rural location of the gypsum mine at Normanswood is shown clearly in this view from Drointon Lane. Worked at different periods since the 1860s, the mine was finally closed in 1951 when these photographs were taken.

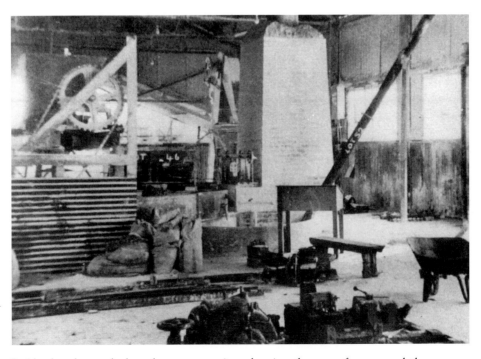

Inside the plaster shed at the gypsum mine, showing the open furnace and the gypsum crusher. The plaster was used to make plaster of paris, cement and blackboard chalk.

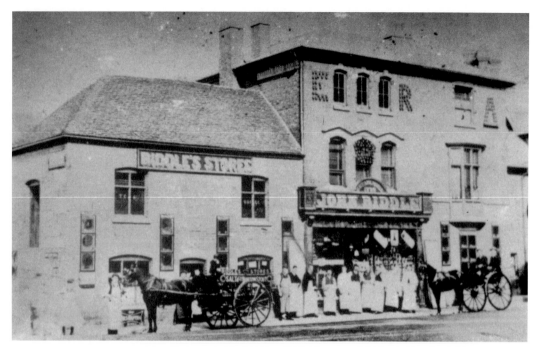

Biddles' Stores, Brook Square, Rugeley, a high class provisions store which started business in 1850. The decorations suggest that this photograph was taken at the time of Edward VII's coronation in 1902.

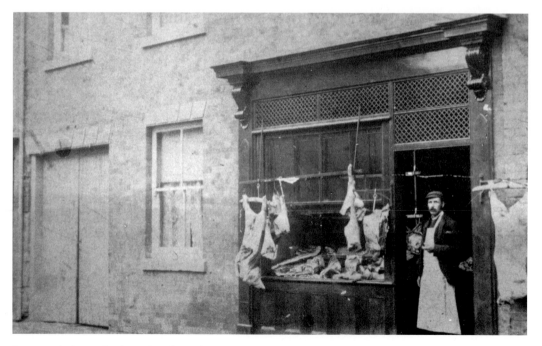

In 1905 Astbury's had two butchers shops in Rugeley. This is probably George Astbury's shop in Albion Street.

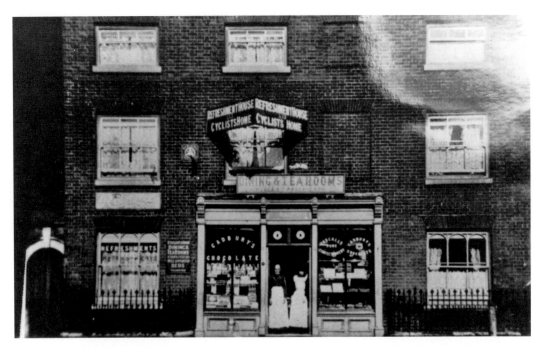

John Morgan's Refreshment House and Cyclists' Home, No. 7, Horse Fair, Rugeley in 1900. The sign on the left advertises 'well-appointed beds'.

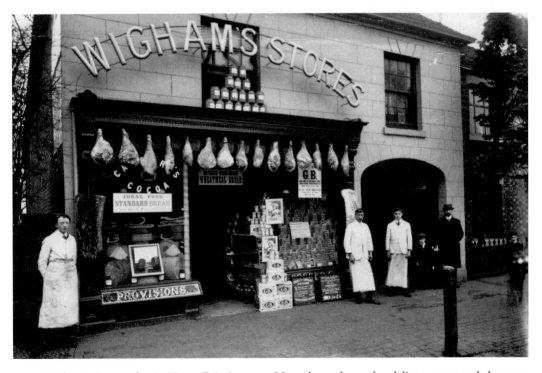

Wigham's Stores also in Horse Fair, in 1912. Note the archway for delivery carts and the posts for use during the horse fairs.

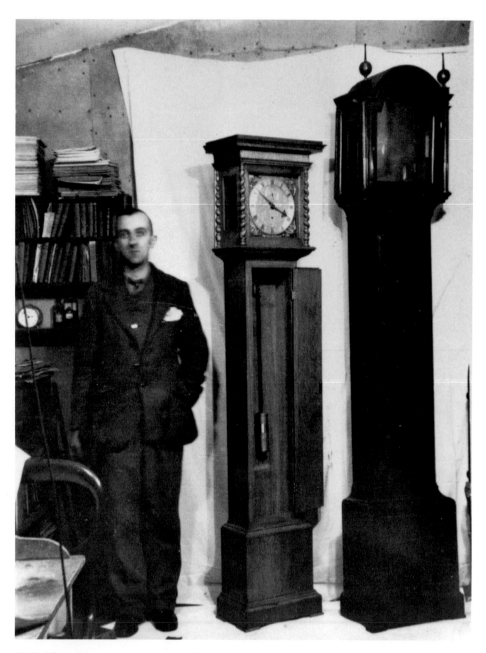

Philip Thornton was an internationally known clockmaker, engraver and restorer of antique clocks in Great Haywood. His workshop was a First World War canteen from Brocton Camp which he rebuilt behind his home, Holmleigh. This photograph was taken in 1929 or 30 in the early days of his career.

P. THORNTON

Engraver and Dial Maker

GREAT HAYWOOD NEAR STAFFORD

Wishes to call the attention of the trade to the fact that he can undertake any work of the following description :—

Inscription Engraving on Brass, Silver, etc.
LETTERED IN ANY STYLE

PRESENTATION & NAME PLATES

Brass Clock Dials (supplied to order)
ENGRAVED, WAXED, LACQUERED

OLD DIALS RESTORED AT LOWEST PRICES

Hand-Pierced Clock Hands for Antique Clocks

MEMORIAL BRASSES, SUNDIALS etc.

*Work collected from all regular customers
in the district.*

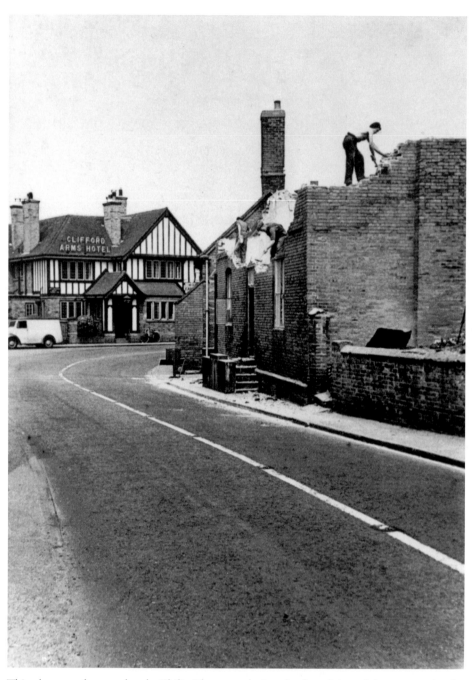

This photograph was taken by Philip Thornton during the demolition of the cottages by the Square in Great Haywood. The Clifford Arms opposite had been rebuilt in 1930 and, at a time of high unemployment, men queued for jobs on the rebuilding.

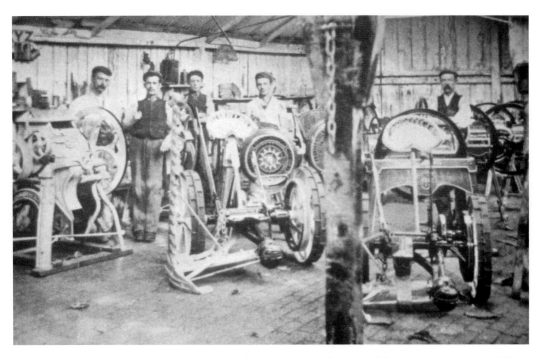

Workers at the Phoenix Ironworks, Market Street, Rugeley, owned by R. J. Harris & Son. These brass and ironfounders made agricultural and dairy equipment.

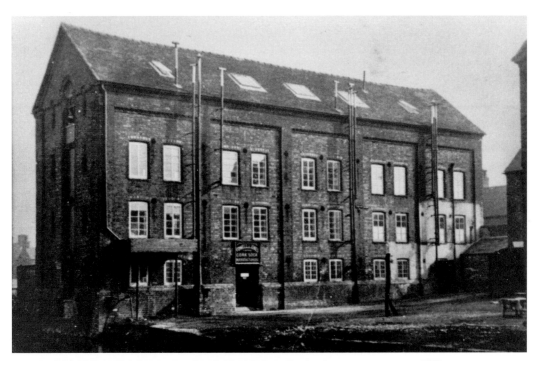

The factory of Fowell & Jones, Rugeley, which made cork soles for shoes and provided work for girls at a time when there was little choice of employment for them other than going into service.

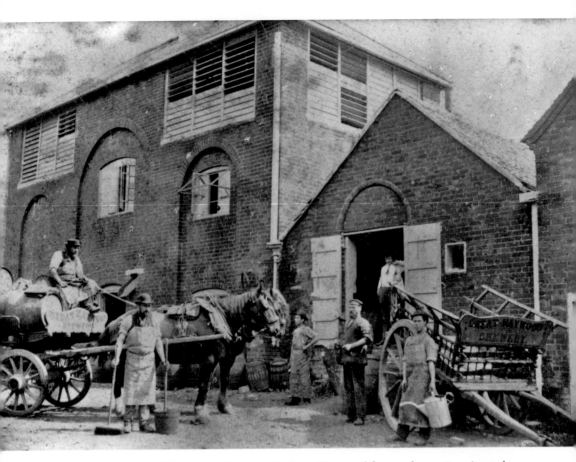

Great Haywood Brewery. There was a brewery in Great Haywood from at least 1851 situated on what is now Brewery Yard and Brewery Lane. This photograph was taken probably in the 1890s when Allen & Sons were brewsters and maltsters there.

Three

Getting About

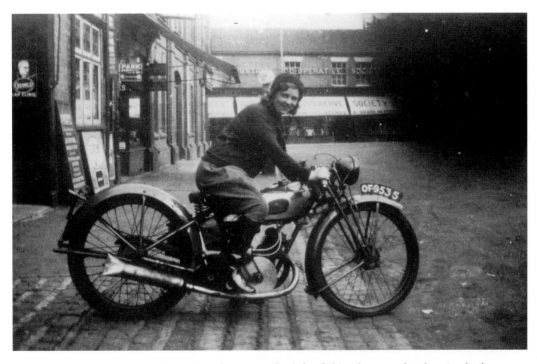

Degg's Garage, Anson Street, Rugeley, is on the left of this photograph taken in the late 1920s. The intrepid young lady on the motorbike is the daughter of the owner, Mr Alfred Degg. He learned to build and repair bicycles at BSA Works in Birmingham and returned to Rugeley to start a bicycle business. This expanded into a garage and a taxi busines.

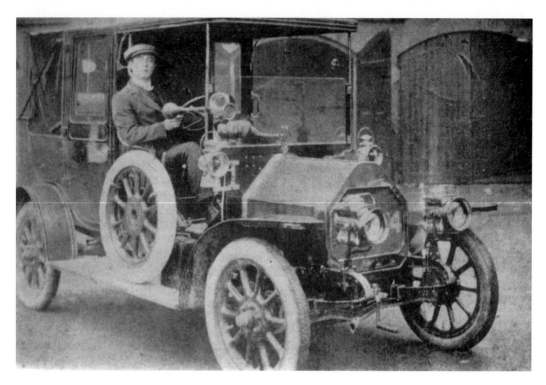

These fine old cars were used as taxis by Deggs.

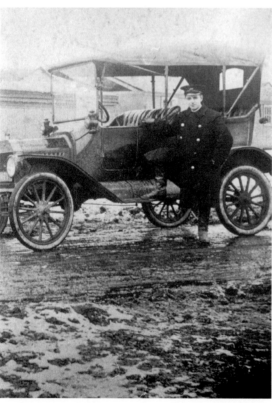

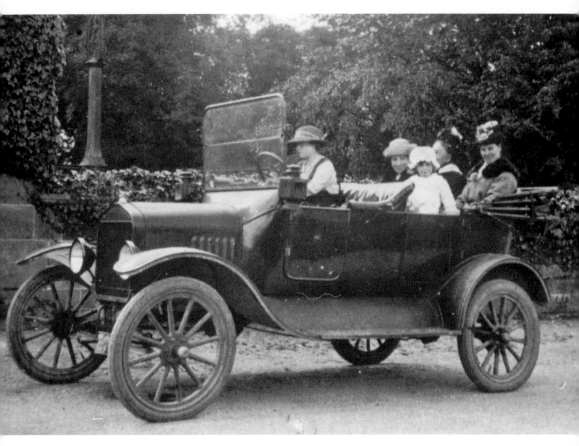

During the First World War there was a demand for transport between Rugeley and the army camps on Cannock Chase. This car was driven by Doris Degg, only 16 at the time. On one occasion, while hand cranking to start the engine, the starting handle flew back and smashed her elbow; this did not stop her from becoming an accomplished pianist.

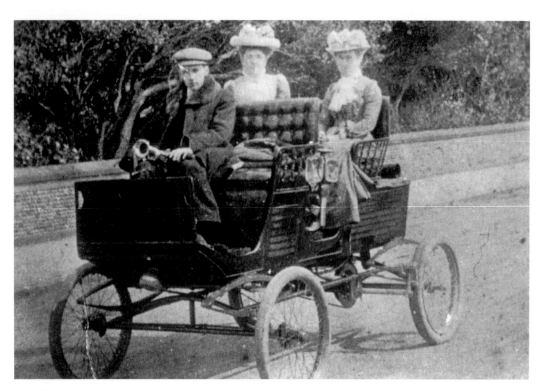

Mr Degg's own car.

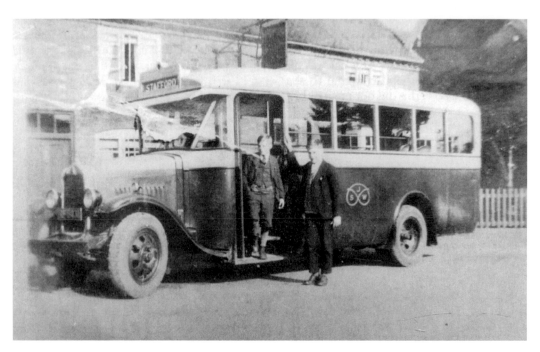

This was the first bus to run from Stowe-by-Chartley to Uttoxeter. It was owned and run by the Robinson family who kept the Cock Inn in Stowe.

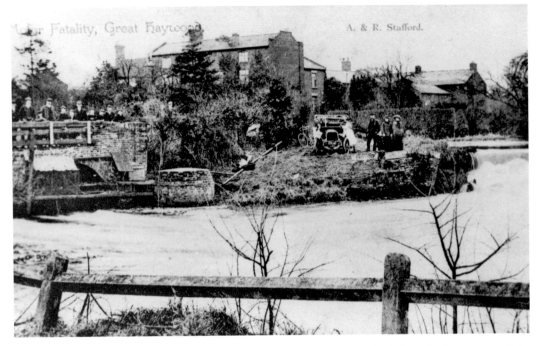

On 9 March, 1905, a car carrying guests from Ingestre Hall crashed through the parapet of the bridge over the Trent at Haywood Mill. The bridge was on a sharp bend. Two women, a Mrs Challenor and her niece, were killed. There was much interest locally, to the extent that postcards were produced of the scene. The road was later straightened and a new bridge built.

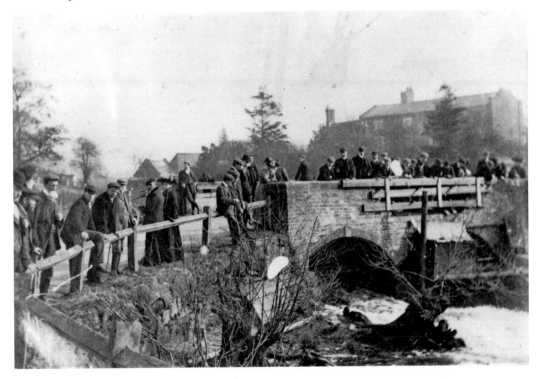

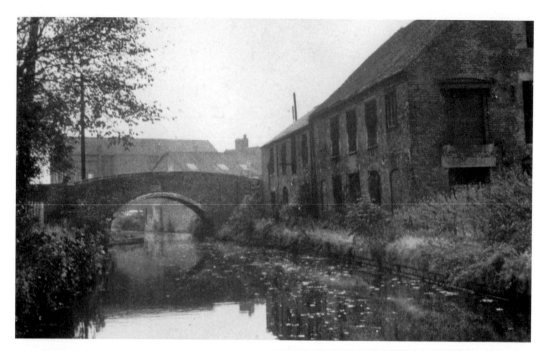

The Trent and Mersey Canal at Rugeley, showing some of the old warehouse buildings since demolished.

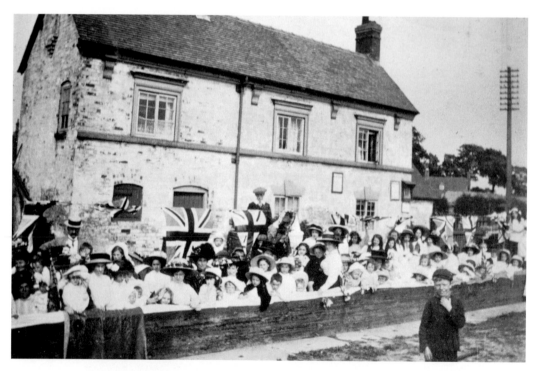

Trips along the canal from Rugeley were a popular Sunday School outing. These Rugeley children are enjoying an outing to Oakedge on Cannock Chase in 1909.

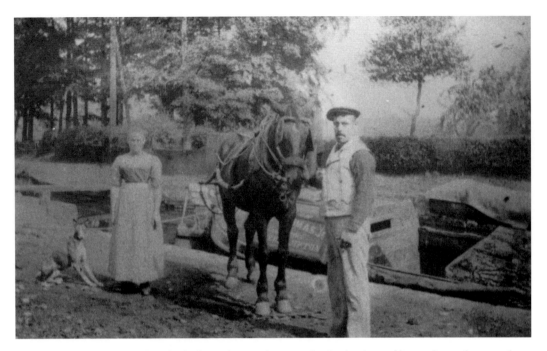

Boat people pictured at the lock on the canal at Rugeley in the days of horse drawn barges, about 1911. The boat was registered at Wolverhampton.

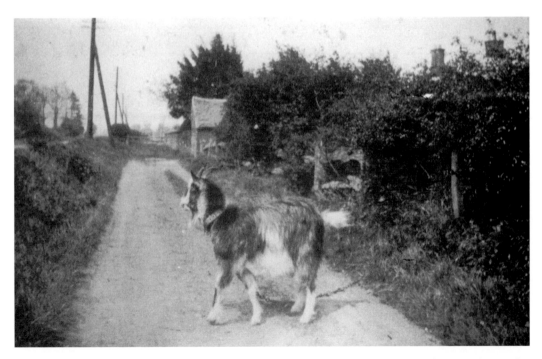

Lycett's goat, a somewhat unusual obstacle on the towpath at Mossley. This photograph was also taken about 1911.

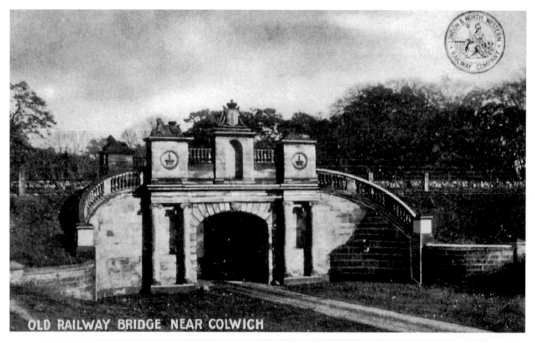

OLD RAILWAY BRIDGE NEAR COLWICH

In 1847, when the Trent Valley Branch of the London and North Western Railway was constructed. The Earl of Lichfield would only allow it to pass through his parkland in Shugborough by means of a tunnel. These two ornate entrances were constructed at either end.

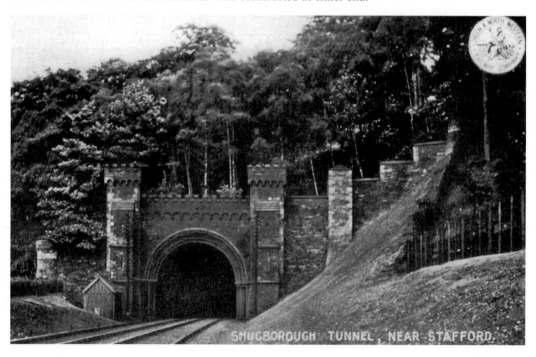

SHUGBOROUGH TUNNEL, NEAR STAFFORD.

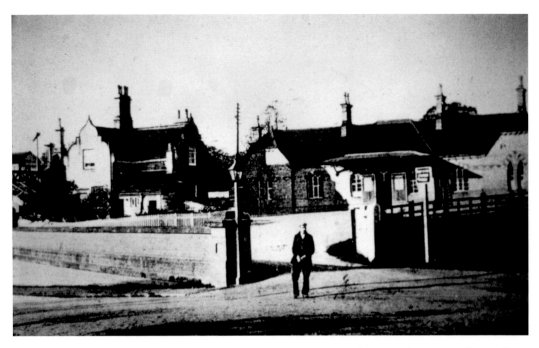

The railway station at Colwich marked an important junction between the Trent Valley Railway, opened in 1847, and the North Staffs Railway, opened in 1849.

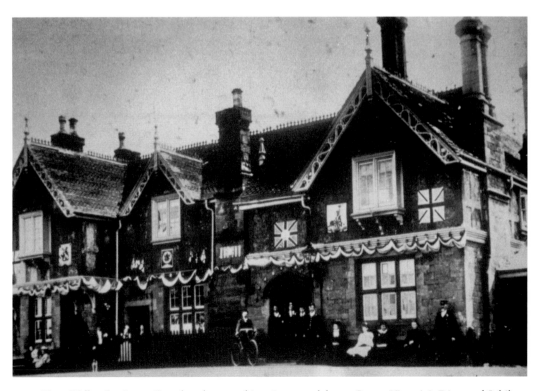

Trent Valley Station at Rugeley, decorated in 1897 to celebrate Queen Victoria's Diamond Jubilee.

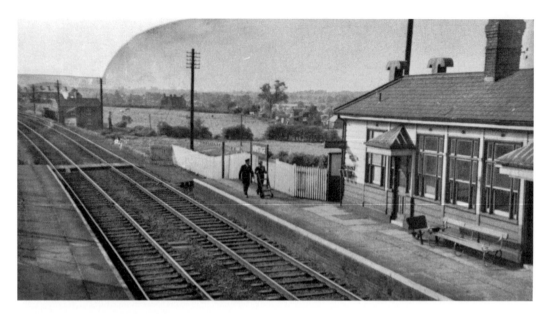

These two views of Armitage Station show its rural situation.

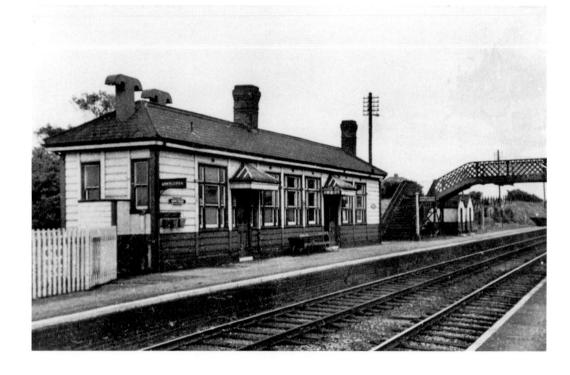

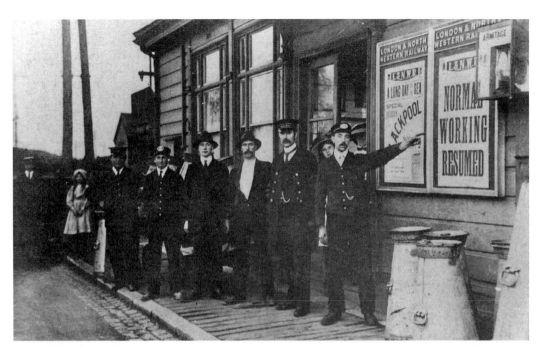

Staff at Armitage Station in 1926. The photograph was taken just after the end of the General Strike, hence the notice on the right. Note the milk churns awaiting collection.

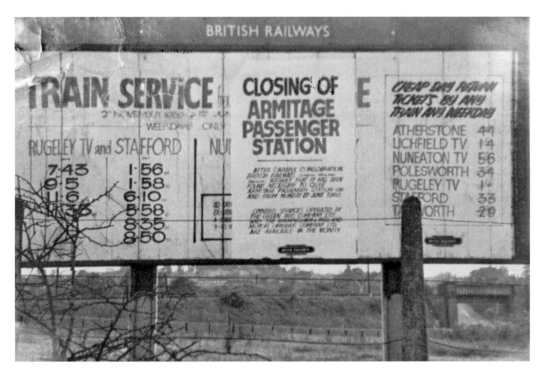

A notice outside Armitage Station displays the timetable and fares. Sadly, it also carries the notice of the station's closure on 13 June, 1960, a casualty of railway rationalisation.

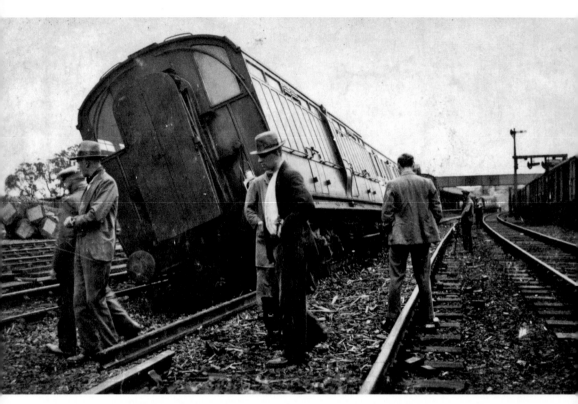

This train was derailed at Rugeley's Trent Valley Station during the 1930s.

Four

Home Sweet Home

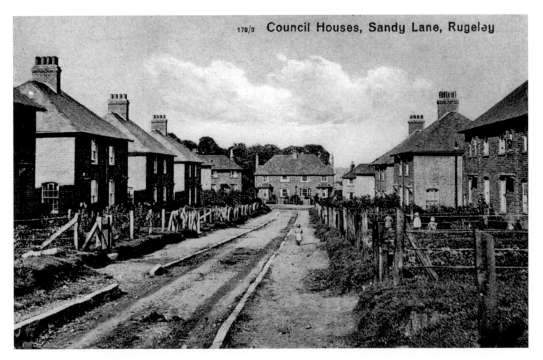

These Council Houses were built in Rugeley between Burnthill Lane and Sandy Lane in the early 1920s. At the time they were very up-to-date, with indoor sanitation, and some had four bedrooms.

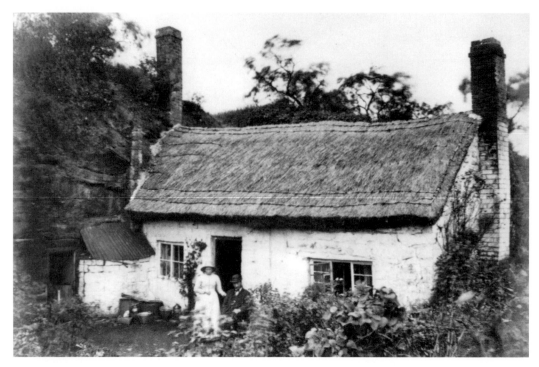

Rock Cottage, Wolseley, 1867. This cottage stood opposite to Wolseley Mill and was built into the rock, hence its name. The recess in the rock where the cottage once stood still exists.

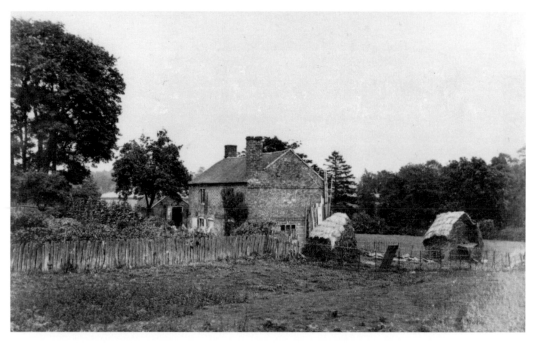

Thatched ricks outside labourers' cottages on the Chase, 1867. This photograph and the one above are from an album of early and rare photographs of Cannock Chase and the surrounding area.

Elm and Oak cottages at Brereton Hayes. Hayes Colliery was just below these houses and the children who lived there spent hours watching the tubs, full of pit waste, swinging along the wires until they were emptied onto the spoil heaps.

These tenement houses were in Elmore Lane, Rugeley, and were called the 'London Houses'.

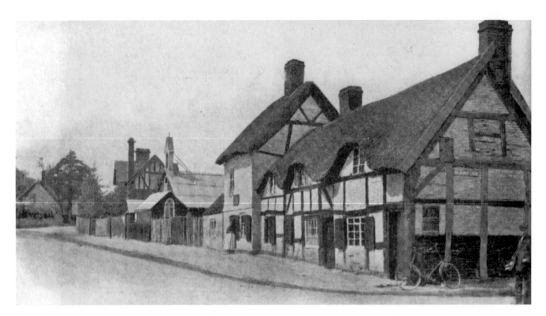

These old cottages were at the corner of Sandy Lane and Elmore Lane, Rugeley. St Mary's Mission next to them was known locally as the tin tabernacle.

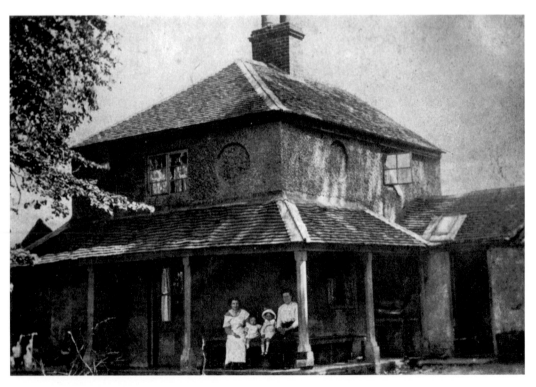

The lodge at the top of Burnthill Lane, Rugeley. This was one of the lodges of Hagley Hall.

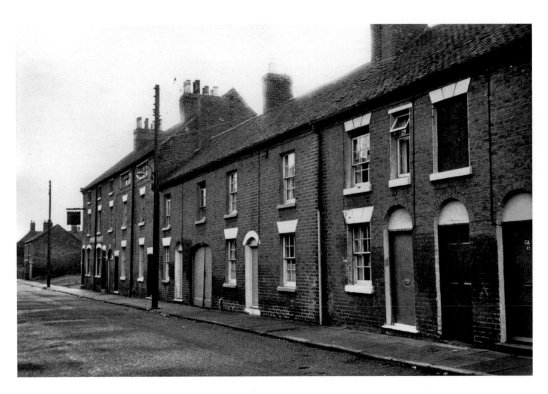

Queen Street, Rugeley, 1974. This street
of terraced houses was off Forge Road,
opposite what is now a large supermarket
car park. The Victoria Inn stood on the
corner.

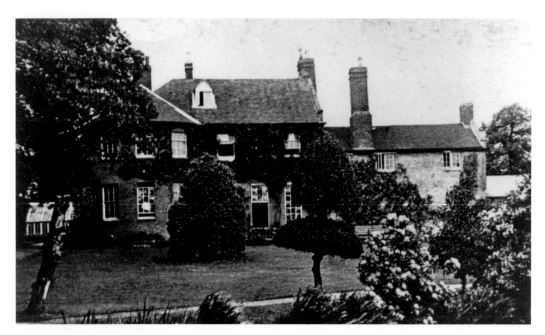

Ravenhill House, Brereton, from the rear.

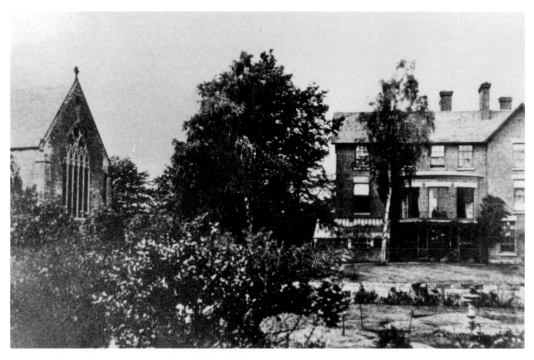

A rear view of Colwich Vicarage and its garden, now demolished and replaced by private houses.

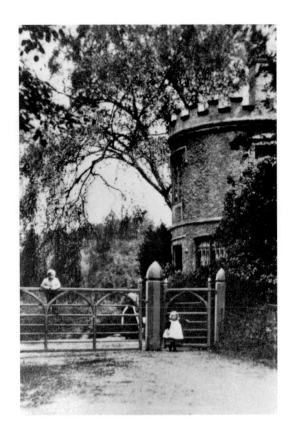

Right: Pepperpot Lodge at Hawkesyard Priory, Armitage, about 1900.

Below: The Lodge House at Castle Ring, one of the entrances to Beaudesert Park, about 1910.

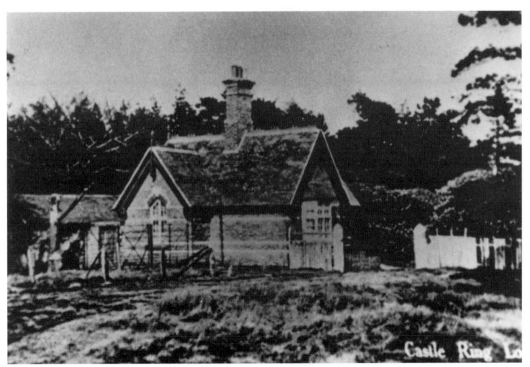

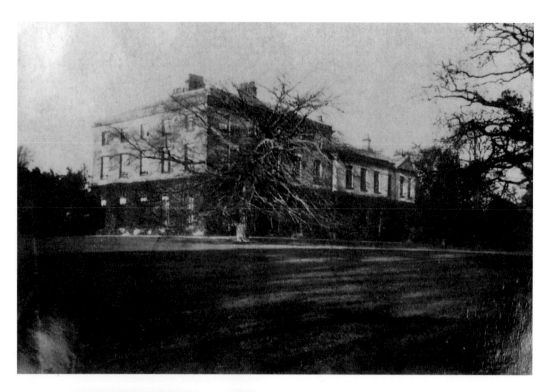

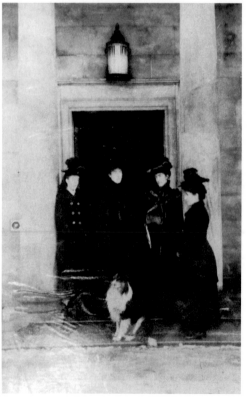

Above: Bellamour Hall, Colton. This house was bought in 1857 by Thomas Berry Horsfall, a Liverpool merchant. The village of Colton in particular benefited from his generosity.

Left: Mr Horsfall's four daughters, Beatrice, Gwendoline, Eva and Gertrude (Truda), with Boy the dog, on the steps of the slate door at Bellamour, in about 1896. None of the sisters ever married.

Two visitors outside the main entrance of Beaudesert Hall, the former home of the Marquesses of Anglesey on Cannock Chase.

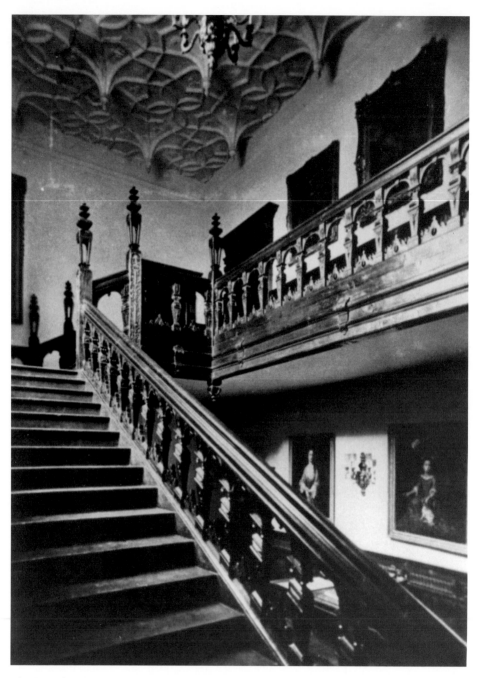

The Waterloo Staircase, Beaudesert Hall. The staircase was named after the battle in which Lord Paget, later the first Marquis, distinguished himself. After the house was sold in 1935, this staircase, together with the interior woodwork, was shipped to Australia, where a house called Carrick Hill was built near Adelaide to accommodate it.

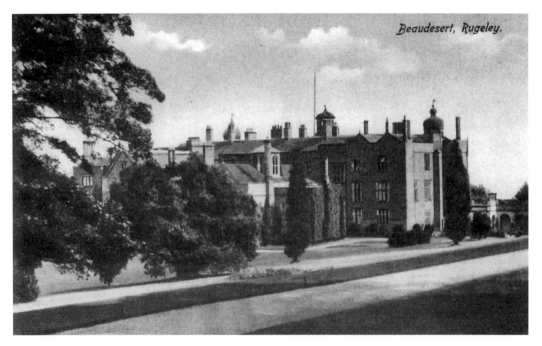

The exterior of Beaudesert Hall. Originally an Elizabethan house, it was the Staffordshire home of the Paget family from the sixteenth century. Following its sale in 1935, it was demolished.

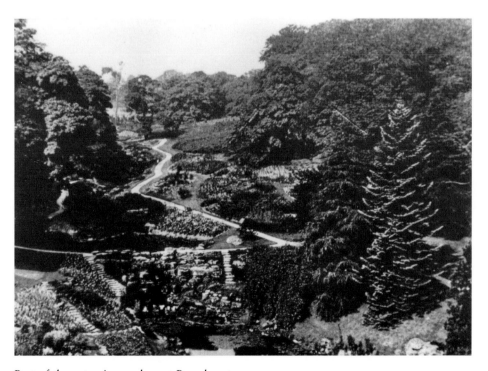

Part of the extensive gardens at Beaudesert.

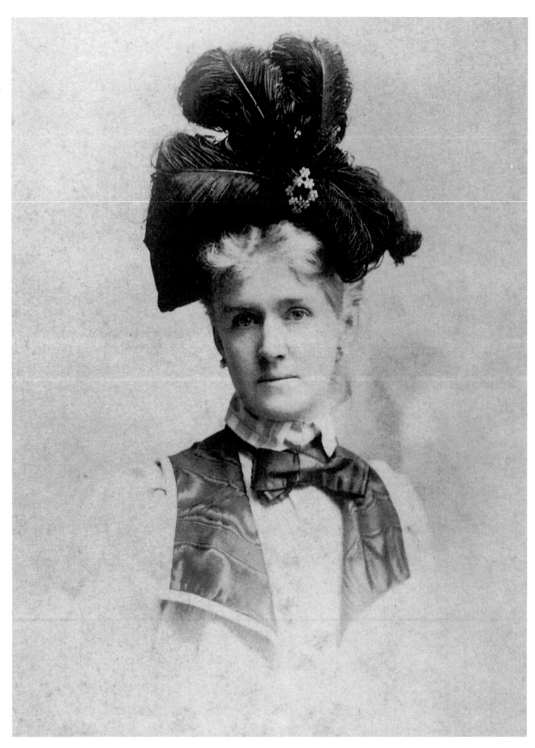

Lady Anita Wolseley of San Francisco, photographed in 1888. She became known as the American Lady Wolseley.

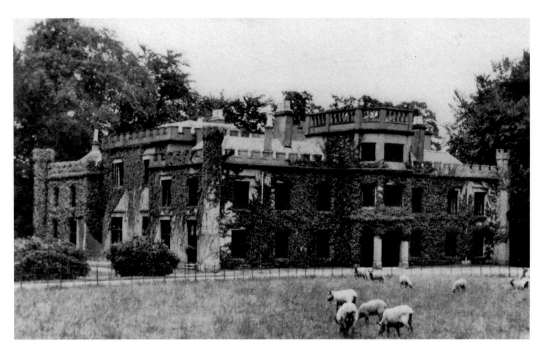

Wolseley Hall about 1904, the home of the Wolseley family. The hall was demolished in the 1950s.

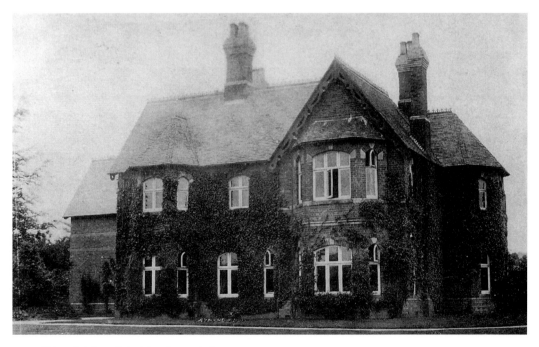

'Riverdale' at Colwich, pictured about 1910.

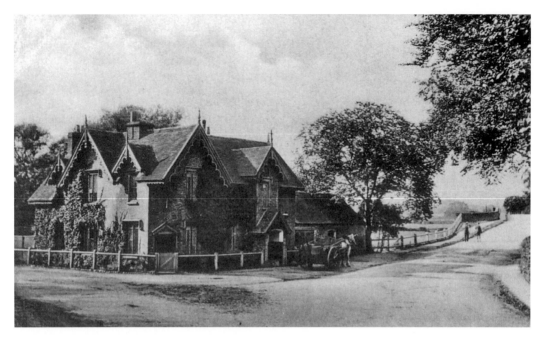

The Roebuck Inn at Wolseley Bridge, now called the Wolseley Arms.

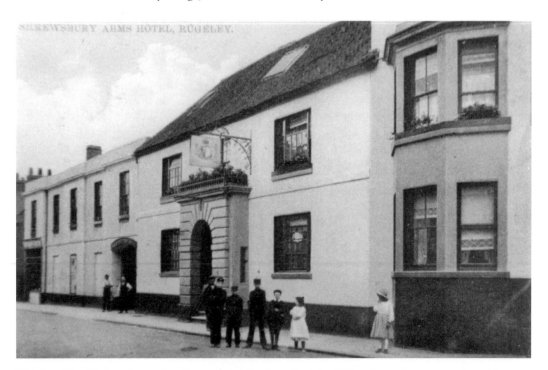

This hotel in Market Street, Rugeley, was originally called the Talbot Arms. By 1905, when this photograph was taken, it had become the Shrewsbury Arms. This change probably took place soon after 1858, when the 5th Baron Talbot successfully claimed the title of the 18th Earl of Shrewsbury.

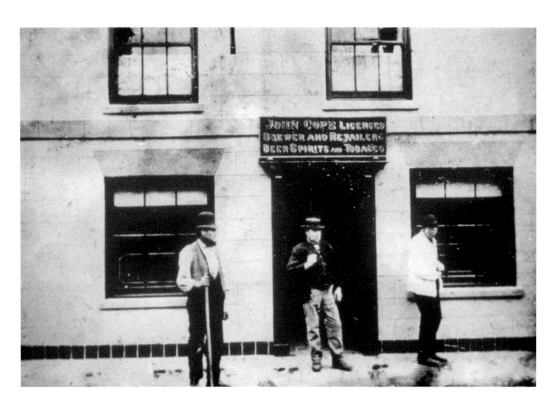

Above: An early photograph of the Crown Inn in Upper Brook Street, Rugeley. John Cope was the licensee between 1860 and 1868.

Right: The Dog and Partridge was in Lower Brook Street, Rugeley.

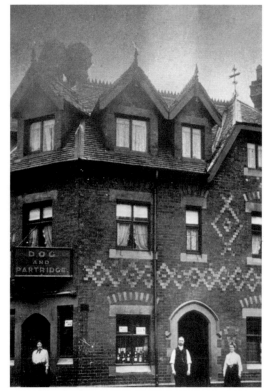

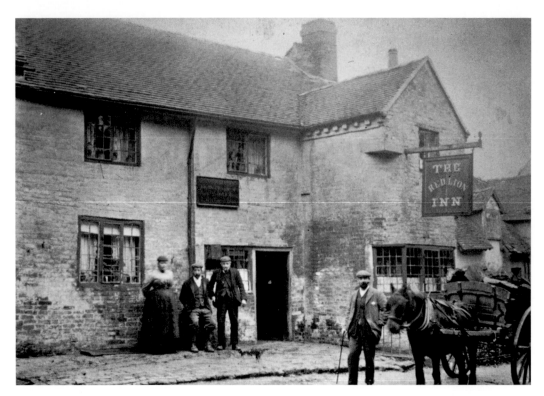

This splendid photograph is of the old Red Lion at Little Haywood which stood on the same site as the present one. Unfortunately it is not possible to read the name of the licensee which would help to date it.

Five

Spare the Rod...

Children paddling at the ford, Old Road, Armitage, about 1900. Note how formal their clothes are for such informal activity.

Shooting Butts Camp for Boys near Rugeley. This was one of the camps set up under the auspices of the National Camps Movement during the Second World War. Shooting Butts continued as a residential secondary school after the war until it closed in 1971. It also had an annex at Pipewood, Blithbury.

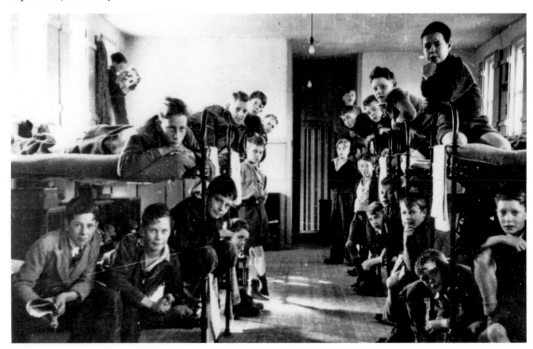

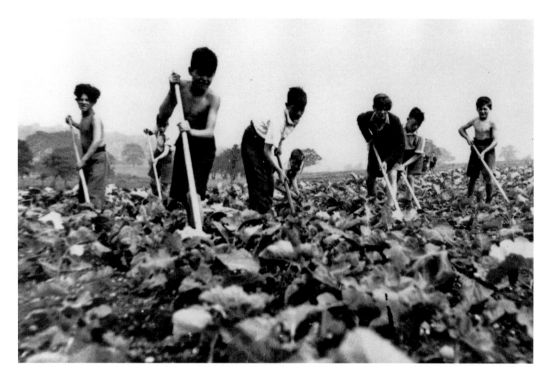

The gardens at Shooting Butts. The camp manager in the 1940s was Mr Kenneth Maxwell, who was a very keen gardener himself. The result of his labours and those of the boys can be seen in these photographs.

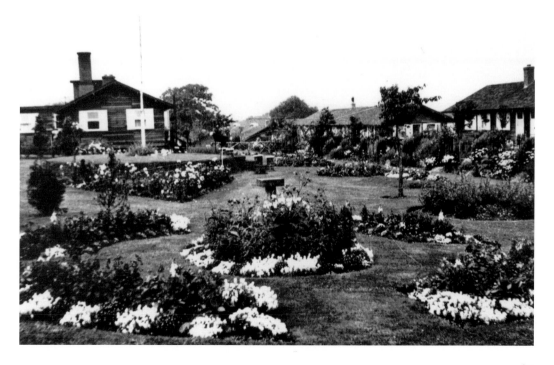

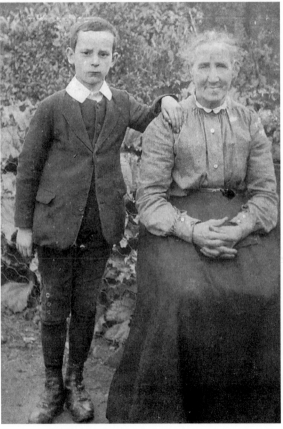

Above: The entrance to Rugeley Grammar School in Colton Road in the 1920s.

Left: This charming photograph shows Annie Wood (see page 6) with one of her grandsons in his Sunday best. It was taken about 1912.

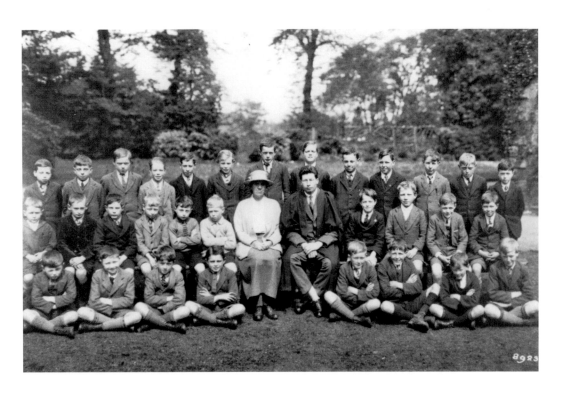

Rugeley Grammar School. These formal photographs were taken in 1924.

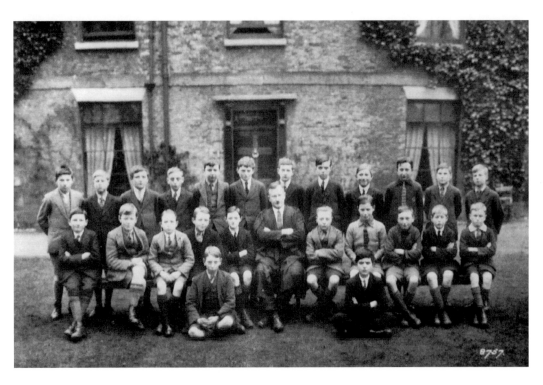

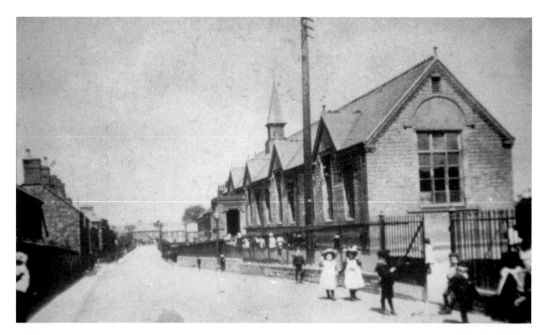

Talbot Street School, Rugeley, about 1905. This School was built in 1894 on land donated by the governors of Rugeley Grammar School. One particular headmistress of the 1920s was fond of telling her girls, 'I am a colonel's daughter and I want everyone to take a pattern from me'.

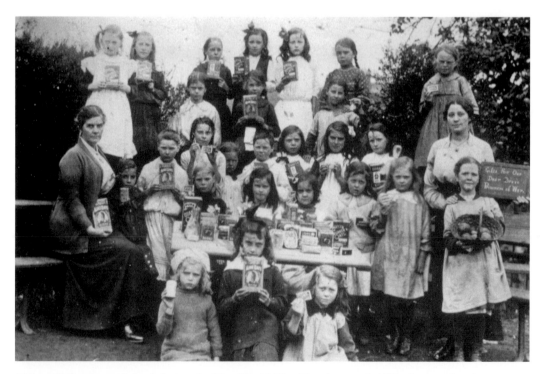

Girls at Talbot Street School during the First World War. The slate reads 'Gifts for our dear brave prisoners of war.'

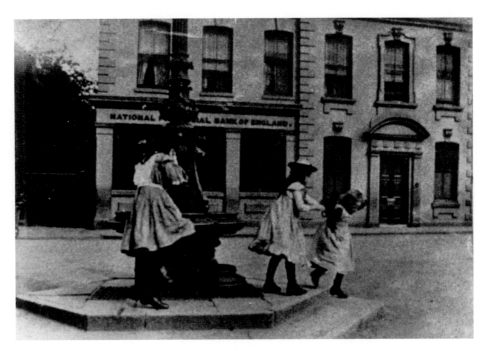

Three little girls playing round the lamp in the Market Place, Rugeley, about 1900. The lamp had drinking fountains on it on four sides and was removed in 1951.

This photograph shows a Congregational Sunday School trip from Rugeley to Seven Springs in Cannock Chase in August 1911. The trip was made by narrow boat from the town wharf to the wharf opposite the Navigation Inn at Little Haywood. The children then walked down to Seven Springs, where they enjoyed games and a picnic.

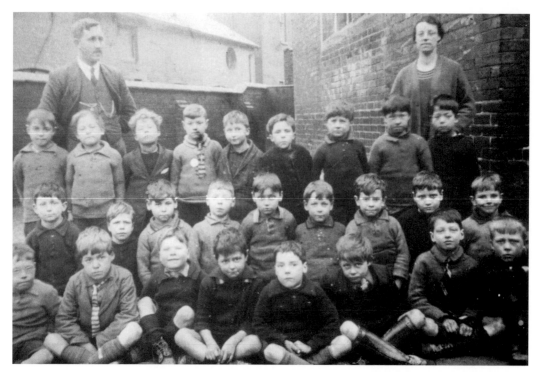

Boys at the Prince of Wales School, Lichfield Street, Rugeley, about 1919. The male teacher was Mr Brown and the lady could be Miss Andrews.

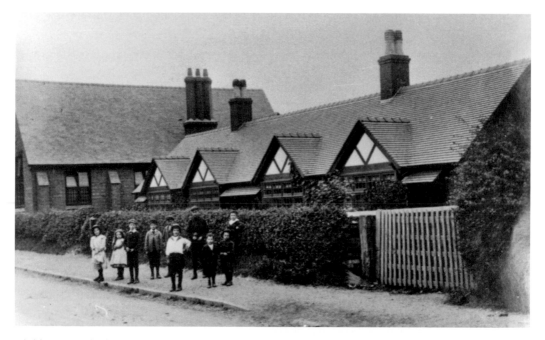

Children outside the almshouses in Brereton which were built by the Reverend Samson for poor widows.

90

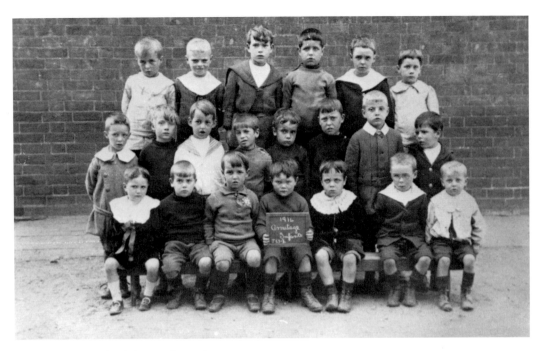

Armitage School, boys infants class, 1914.

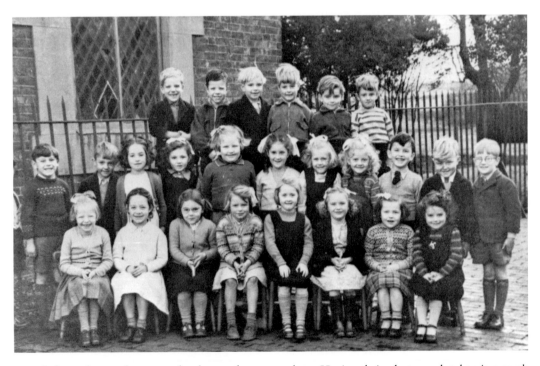

Infants class at the same school some forty years later. Having their photograph taken is a much less daunting experience for these children!

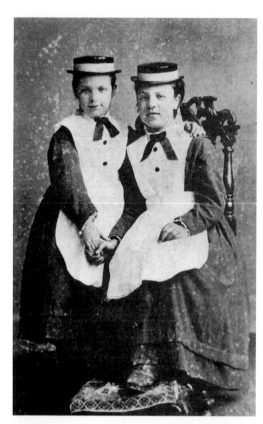

During the late nineteenth century Mrs Elizabeth Harland, the wife of the vicar of Colwich, ran a small orphanage for orphan girls at Colwich Vicarage, which then stood on the present site of the Moorings. She is pictured below with some of the girls. As Mrs Harland died in 1889, these photographs predate this.

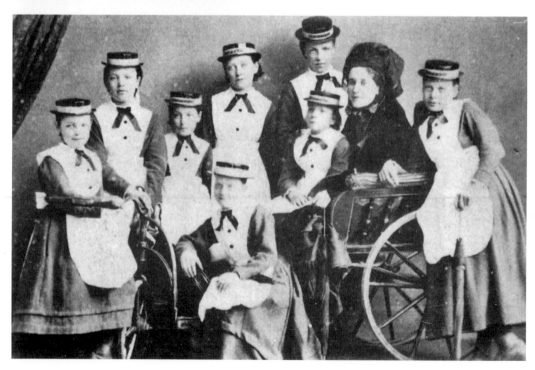

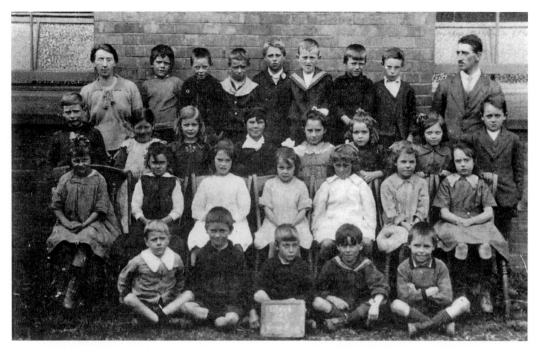

Class group at Colwich Church of England School in 1914. The school was founded by Miss Charlotte Sparrow of Bishton. The teacher on the extreme left of the back row is Mary Cliff.

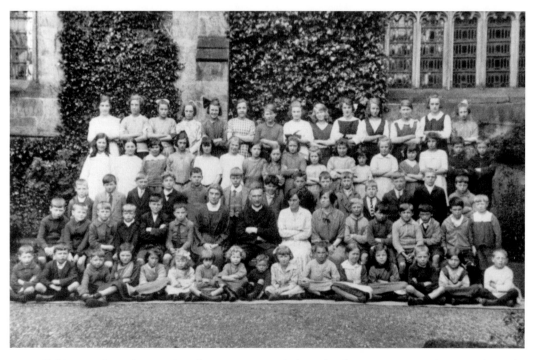

Children and teachers at St John's Roman Catholic School, Great Haywood, pictured on the occasion of the retirement of Miss Monica Hill, the headmistress, in 1923.

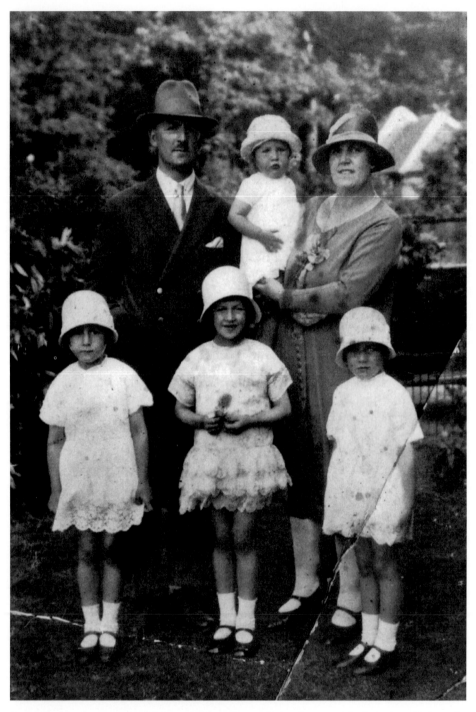

A delightful photograph of Mr and Mrs Watts of Handsacre with their four little girls. Mr Watts was the policeman at Handsacre.

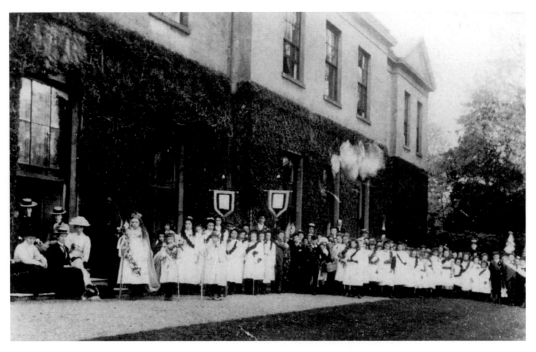

The May Day procession of Colton children outside Bellamour Hall during the 1890s. Mrs Horsfall of Bellamour and her daughters are seated on the extreme left.

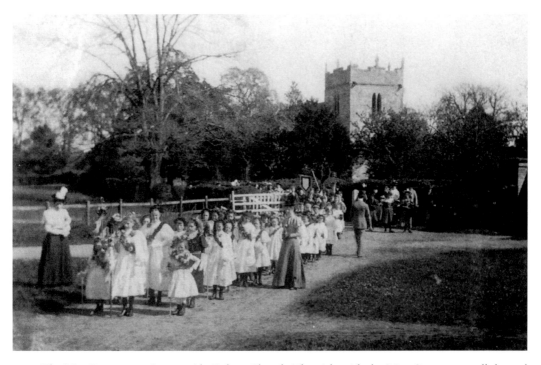

The May Day procession outside Colton Church. The girls with the May Queen were all dressed in white and wore flower sashes, while the boys dressed as tradesmen.

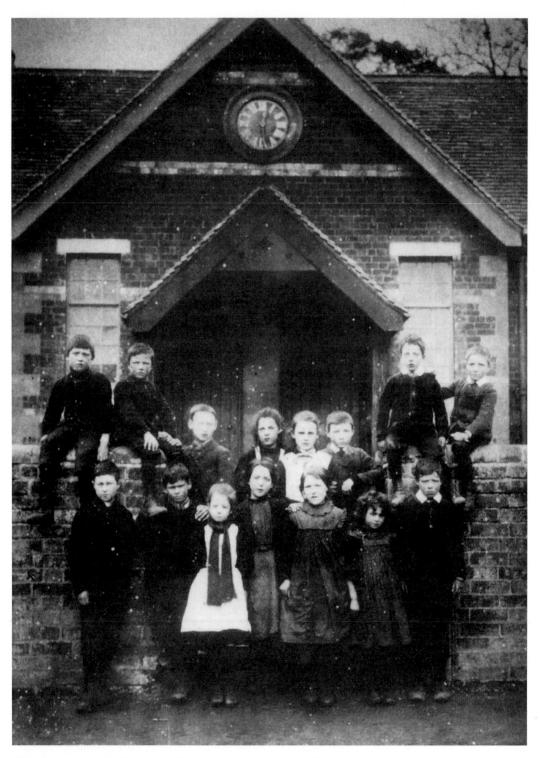

This photograph of children outside the entrance to Colton School was taken in 1894 and shows all the children who had not been absent for a single day during the whole year.

Six

For King and Country

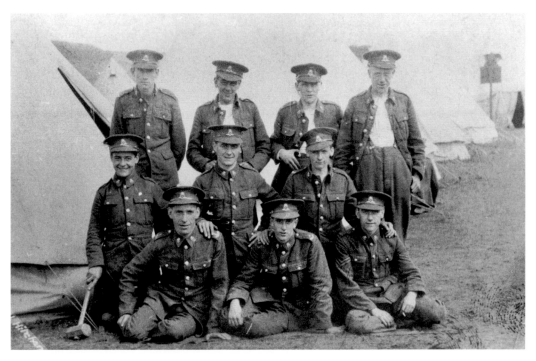

Rugeley Territorial soldiers at camp about 1928.

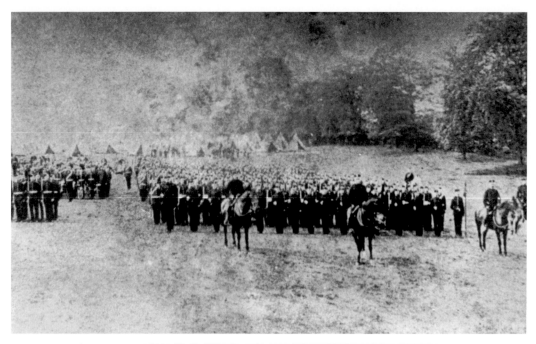

Rugeley volunteers in Hagley Park in 1891.

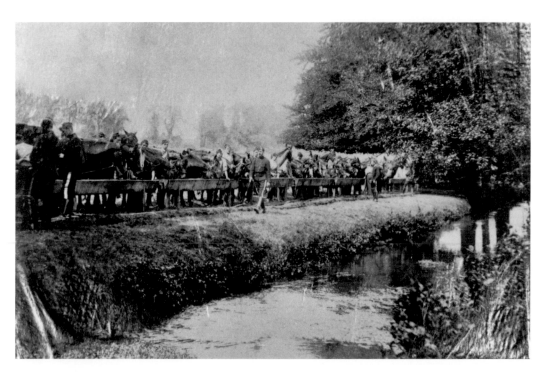

Cannock Chase was used regularly for military manoeuvres in the late nineteenth and early twentieth centuries. These manoeuvres took place in the 1880s.

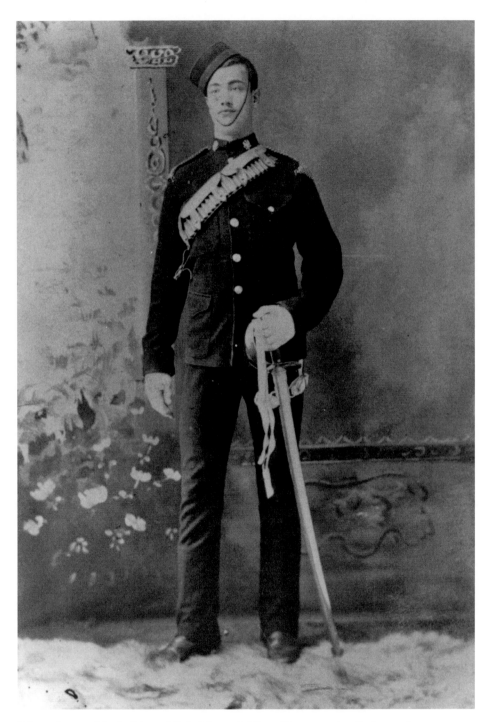

Private Leonard L. Judkins of Colwich, 14th Kings Hussars, who died on 4 January 1903 on active service during the Boer War at Kroonstad. His comrades placed a brass tablet to his memory in Colwich Parish Church.

A VETERAN INDEED !

SERGEANT-INSTRUCTOR ALLCHIN,
OF RUGELEY. BORN 1814.

SERVICE—

Enlisted in the 2nd Queen's Royal Sussex
Regiment in 1833,

1st Afghan Campaign (6 Engagements and
the Relief of Candahar).

21 Years with the Colours.

12 Years in Staffordshire Militia.

22 Years Instructor to the Rugeley Volunteers

*Making 55 Years Service for his
Queen and Country.*

PHOTO TAKEN IN HIS 92ND YEAR.

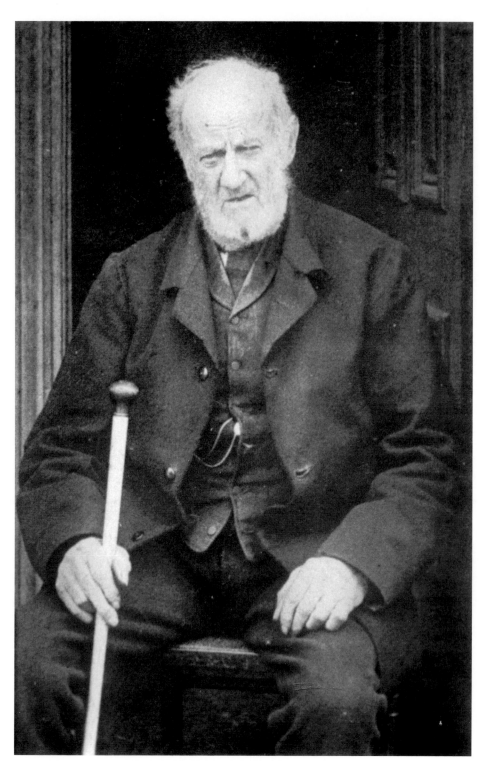

Sergeant Instructor Allchin of Rugeley. A true veteran!

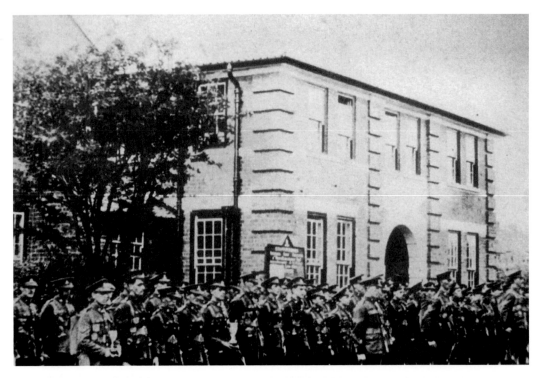

Members of the Territorials on parade outside the Drill Hall in Rugeley. The occasion is not known, but the soldier on the extreme left, front row, and the fourth man along from him are holding presentation cups.

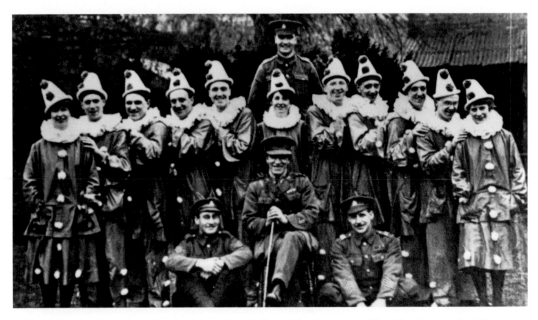

This troop of pierrots provided entertainment for soldiers stationed locally during the First World War.

Members of the Royal Flying Corps during the First World War. The young man front left is William Parker of Rugeley, son of Henry Parker, the postman (see page 38).

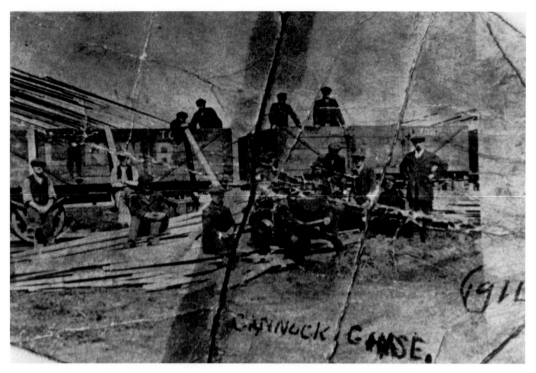

In 1914 a number of army camps were built on Cannock Chase. This photograph shows wood being hauled to one of the sites by rail and workmen waiting to start erecting the huts.

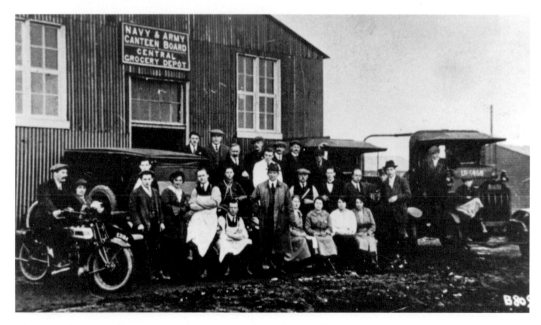

The central grocery depot at Rugeley Camp with civilian staff outside it.

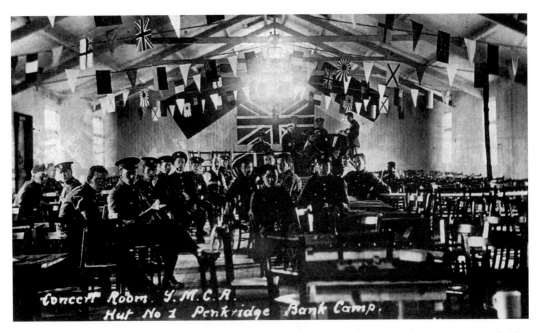

Soldiers in the concert room at the YMCA at Rugeley camp, which was also known as Penkridge Bank Camp.

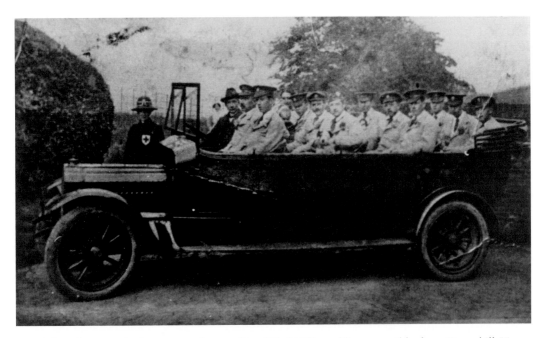

This photograph shows convalescent First World War soldiers, possibly from Ravenhill House being taken for an outing. Notice that the Scottish soldier in the second row also took his little terrier for the ride!

CAMP, RUGELEY.

TO GREET YOU.

THERE are places in England to Rugeley superior,
 In fact, it was known long ago as Siberia!
My word! it is like it,—from towns far away,—
Nothing but Khaki to make the place gay.

It's not too exciting as you may well guess,
For shops there are few and trains there are less,
But men there are plenty to cross the blue sea,
A fine lot of fellows—of course counting me!

Each man has his fairy, not always a Mary,
He thinks of her much as he sings "Tipperary,"
He marches right briskly under weight of his pack,
And dreams that "C.B." only means "coming back"!

And this is from one of them to wish you "good luck,"
He is hoping to prove he's not wanting in pluck,
Here's a handful of love from lone Cannock Chase,
From a lad who just longs for a sight of your face!

[Copyright.] C.F.P.

A wry description of life at Rugeley Camp. The message written on the back of the postcard is a poignant one 'I think of you always whether I am singing 'Tipperary' or anything else. As for longing for the sight of your face, I am pining for a glimpse of you; it seems years since I saw you.'

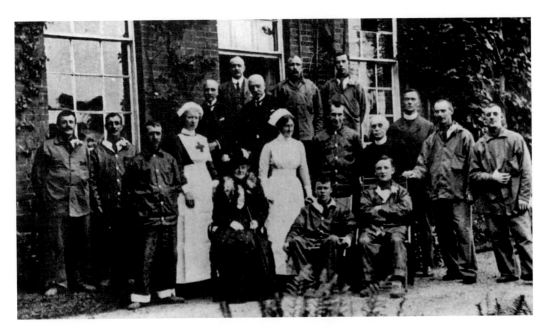

Some wounded First World War soldiers recuperating at Ravenhill House, Rugeley, which was turned into a military hospital for the duration of the War. The occasion was obviously a visit by local dignitaries.

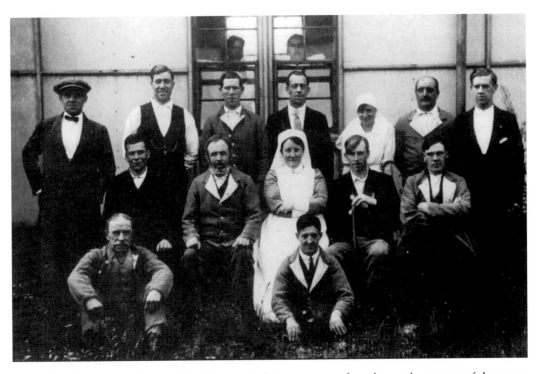

This photograph of wounded soldiers with their nurses may have been taken at one of the camps on the Chase.

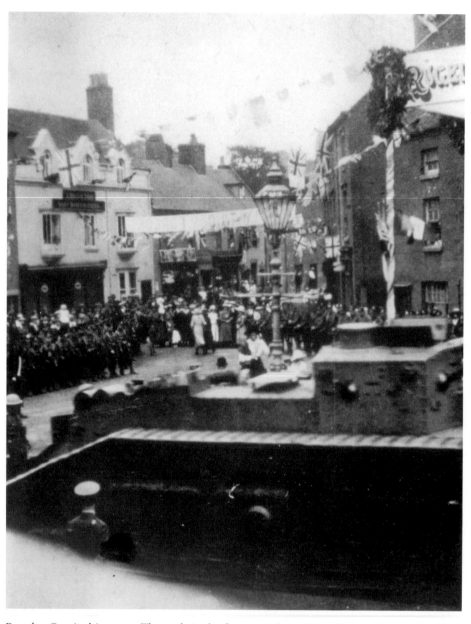

Rugeley Carnival in 1917. The tank in the foreground was brought into the Market Place to help raise funds for the troops.

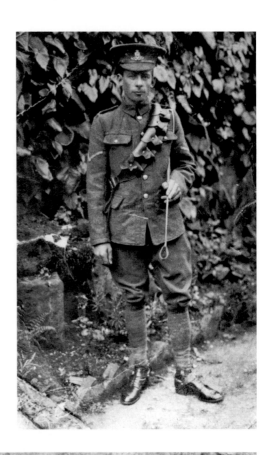

This young soldier lived in Brereton Road, Rugeley. Sadly, like so many others of his generation, he did not return home.

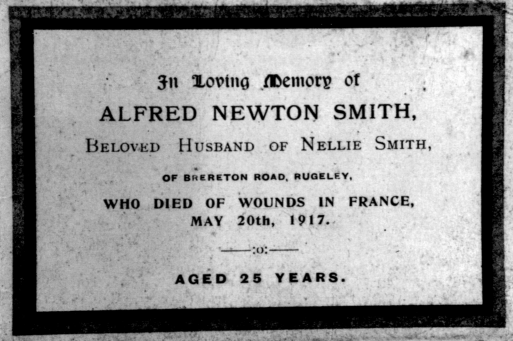

In Loving Memory of
ALFRED NEWTON SMITH,
BELOVED HUSBAND OF NELLIE SMITH,
OF BRERETON ROAD, RUGELEY,
WHO DIED OF WOUNDS IN FRANCE,
MAY 20th, 1917.

——:o:——

AGED 25 YEARS.

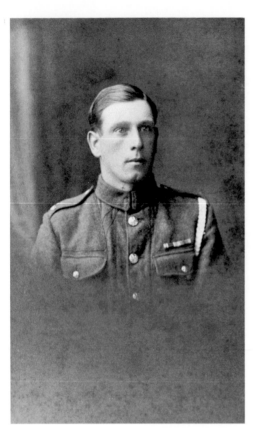

The four Timmis brothers were born in Mavesyn Ridware. All joined up at the outbreak of the First World War and all returned home. Daniel Timmis, the eldest was gassed.

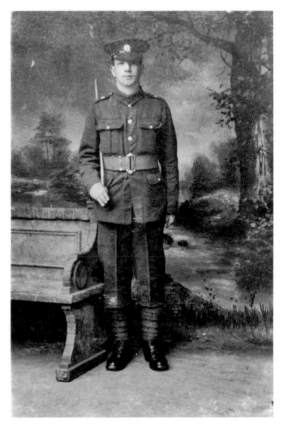

George the second brother, was wounded and was awarded the Military Cross for bravery in the field.

John (Jack) was the third brother.

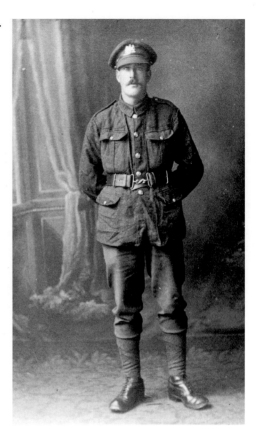

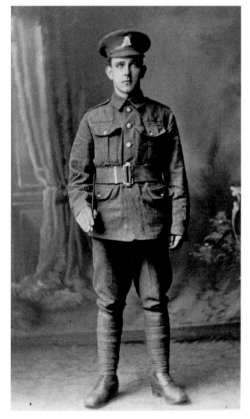

Edward (Ted) the youngest was badly wounded. On
their return home, the brothers all moved to Armitage.

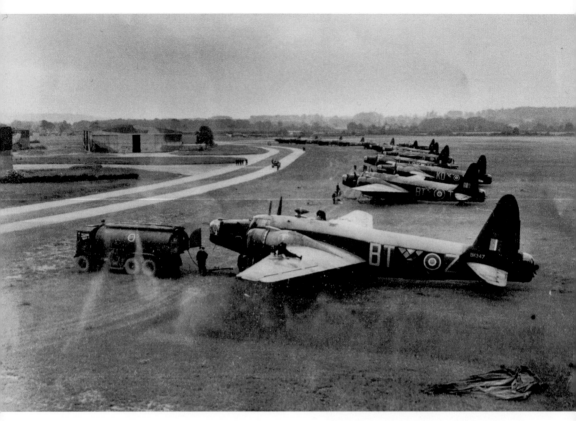

During the Second World War Hixon had a busy airfield. This photograph shows Wellington bombers at the airfield. (Imperial War Museum)

Seven

Joys and Pleasures

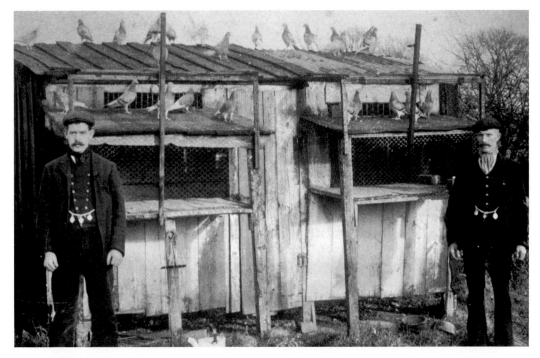

Rugeley Miners valued their leisure hours, which were doubly precious after long hours spent underground. In the 1920s racing pigeons was a passion and there were two pigeon flying clubs, one in Rugeley and the other one in Brereton.

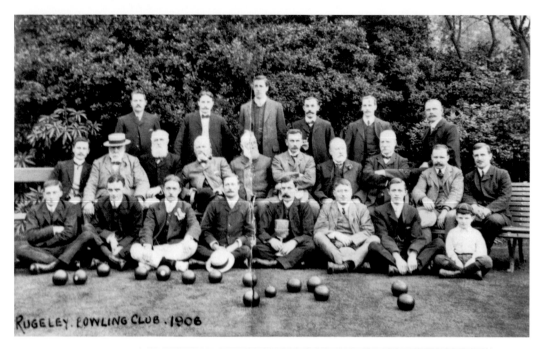

Members of the Rugeley Bowling Club on the bowling green behind the Shrewsbury Arms in 1906. Back row: A. J. Toy, J. A. Bradford, C. Tompson, B. Woolley, B. Hewitt, F. James. Middle row: J. Day, C. Lees, J. Tomson, G. Brown, T. Whittingham, ? Du Prey, A. Bradford, A. Campbell, S. Fairley, R. Boyle. Front row: J. Grimley, J. Tompson, W. Fowell, ? Emery, W. Campbell, O. McGregor, T. Moreton, M. McGregor (?).

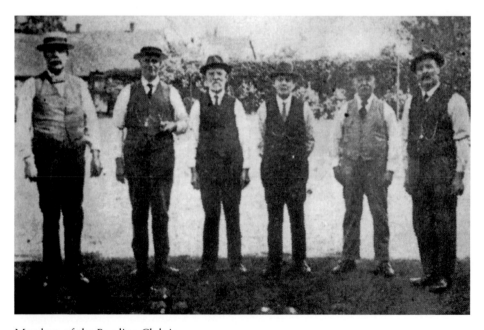

Members of the Bowling Club in 1910.

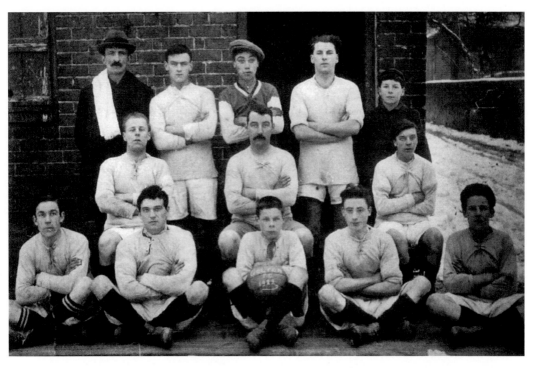

Colton Football XI in 1922. As there was snow on the ground when this photograph was taken, the front row had to sit on a trestle.

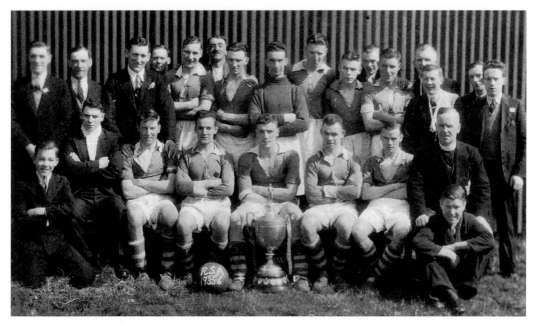

Rugeley St Augustine's football team in 1935-6. The clergman seated with the players is the Revd Lowe. It was quite usual for churches to have their own football teams in the twenties and thirties and, to judge from the large trophy, this was a successful one.

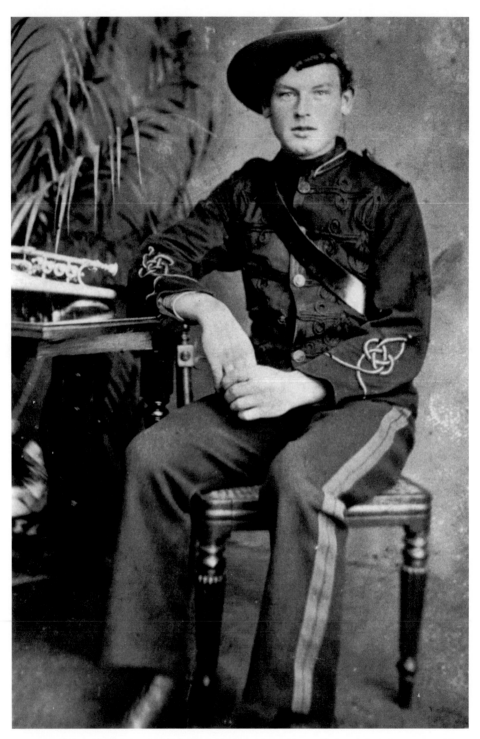

A formal studio photograph of a young Rugeley bandsman. The photograph is difficult to date but the style of the hat suggests that it may be earlier than the photograph of the whole band on the opposite page.

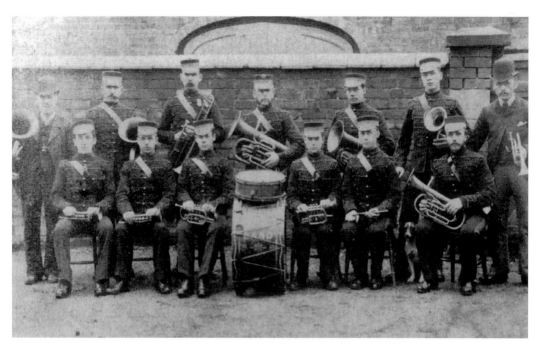

Rugeley Silver Band in the late 1880s. The name of the band is written on the side of the drum.

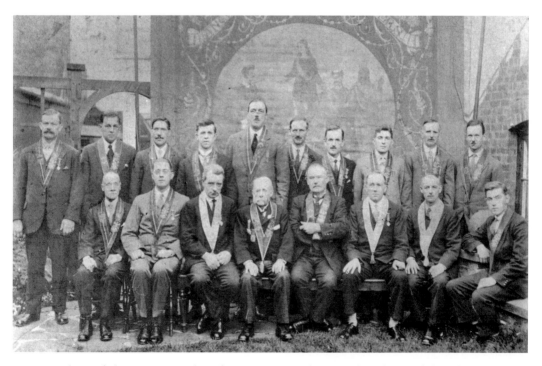

Members of the Ancient Order of Foresters, Rugeley, posed in front of their banner in the 1920s.

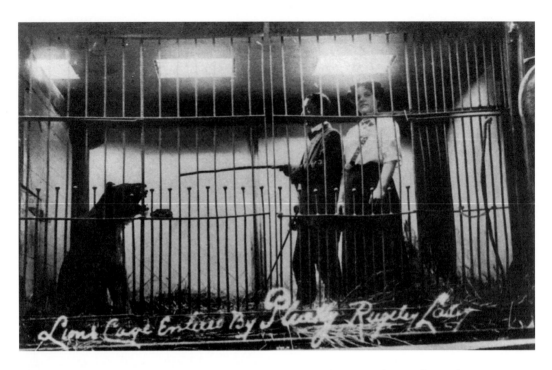

Above: Each year a pleasure fair and menagerie came to Rugeley at the same time as the horse fairs. Prizes were offered to anyone brave enough to enter the lion's cage. This young lady accepted the challenge.

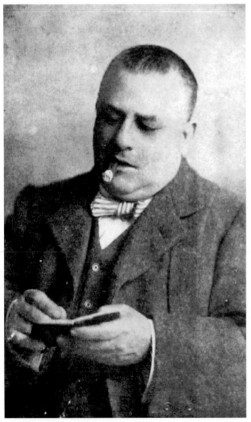

Left: Horace Stanley, whose play 'Parted at the Church' was produced for the first time at the Palace Theatre, in Anson Street, Rugeley, probably in the late nineteenth century.

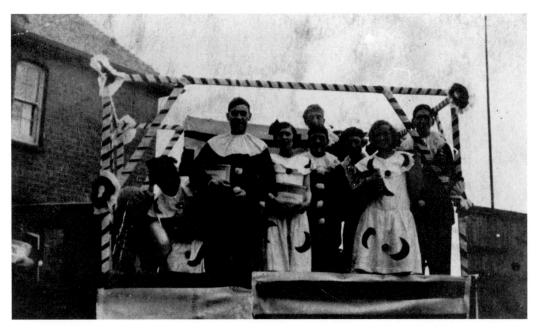

Rugeley Hospital Carnival was held annually to raise funds for the hospital. Floats like this one, photographed in the 1920s, started off from the Tanyard fields and toured the town.

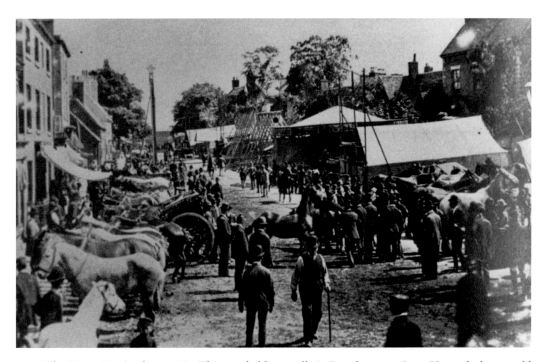

The Horse Fair in about 1880. This was held annually in Rugeley every June. Horse dealers would come from as far afield as Ireland and Scotland and the horses would be trotted up and down to show their paces. The swing boats of the accompanying pleasure fair can be seen clearly in the background.

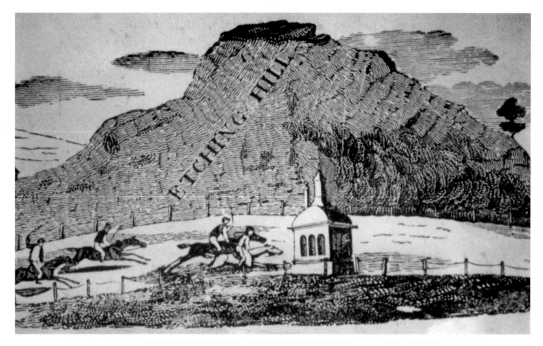

An engraving of Etching Hill racecourse in 1856, which contributed to the downfall and subsequent execution of Dr. William Palmer. His addiction to gambling led him to employ desperate measures to obtain money, including murder.

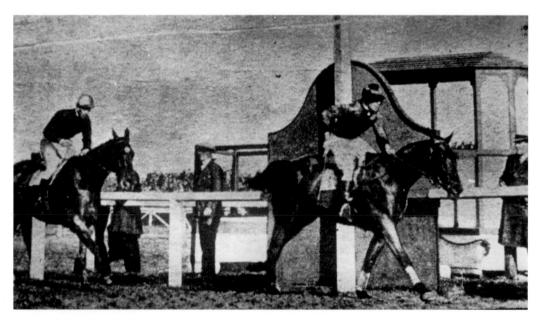

Tom Coulthwaite, the famous local trainer, owned a racing stable at Flaxley Green on the edge of Rugeley in the 1920s. His stables were visited by Edward, Prince of Wales, whilst the Prince was staying nearby. In 1931 Grakle, above, was Coulthwaite's third Grand National winner. As the horse had been backed heavily locally, Staffordshire bookies had a bad day!

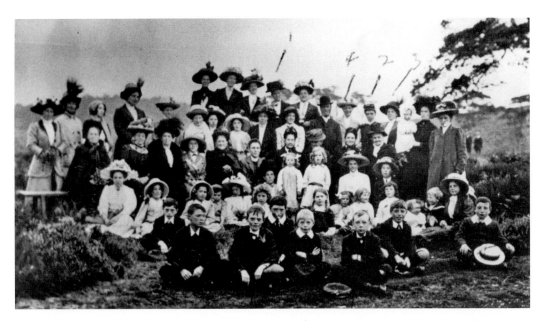

Church outing from Armitage about 1900. These outings were a highlight of the village social calendar and were often preceded by an increase in the numbers of children attending Sunday School.

Market Place, Rugeley, in 1905, the starting place for the annual Sunday School Walks.

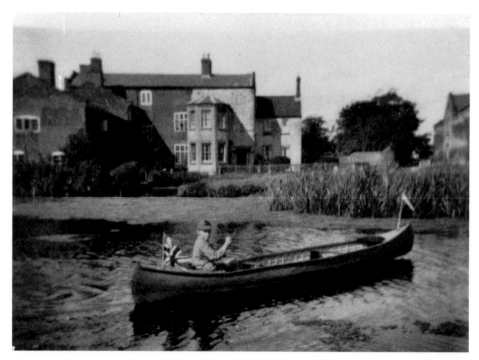

Messing about in boats. On the canal behind Wharf House at Great Haywood in the 1940s.

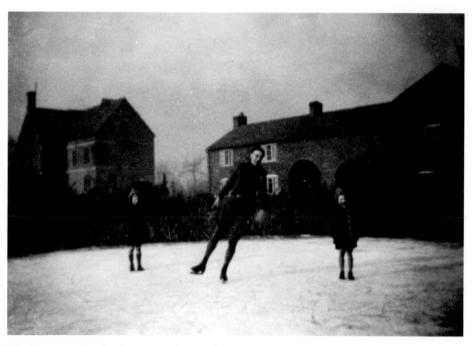

The Thornton family skating on the canal basin at Great Haywood one cold winter in the early 1940s. Haywood Mill, can be seen clearly in the background to the left.

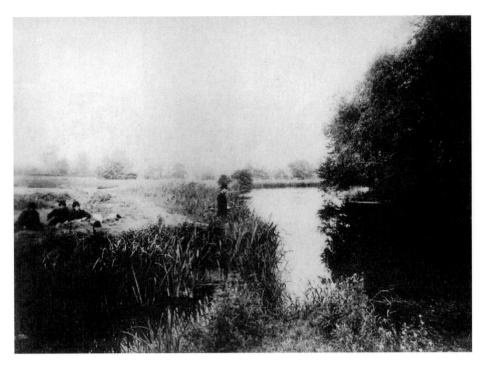

Fishing on the river Trent in Shugborough Park in 1867.

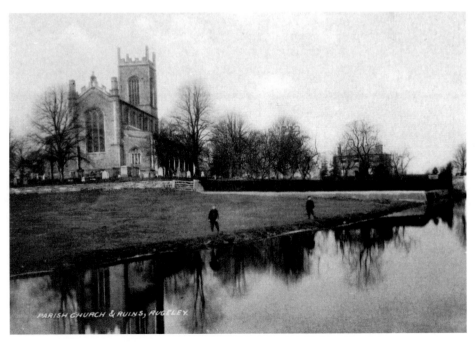

PARISH CHURCH & RUINS, RUGELEY.

A tranquil view of St Augustine's parish church, Rugeley, from the canal, always a popular place for a gentle stroll.

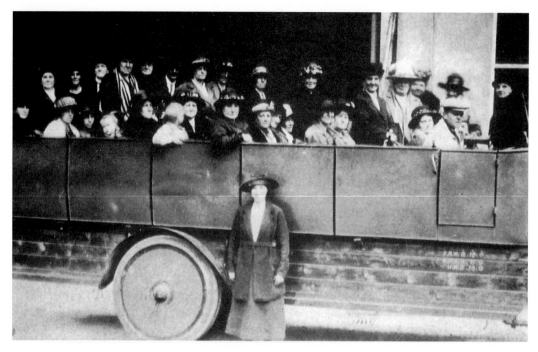

A 1920s charabanc outing to see the waterfall by the Horns Inn at Slitting Mill, another local beauty spot.

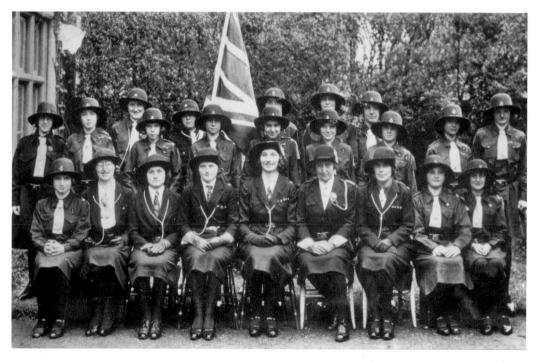

Rugeley Girl Guides pictured during the 1920s. Miss Harris is seated in the centre of the front row.